HUMPBACK WHALES

Hadlow
college

D1348172

Wildlife Monographs – Humpback Whales
Copyright © Evans Mitchell Books 2012

Text and Photography Copyright
© 2012 Kate Westaway

Robin Morgan and Kate Westaway have asserted
their rights to be identified as the authors
of this work in accordance with Section 77 of
the Copyright, Designs and Patents Act 1988

First published in the
United Kingdom in 2012 by
Evans Mitchell Books
54 Baker Street, London W1U 7BU
United Kingdom
www.embooks.co.uk

Text and Photographs by Kate Westaway
Designed by Stephen Reid
Edited by Robin Morgan
Research by Alice Ter Haar
Graphics by Ian Moores

British Library Cataloguing in Publication Data.
A CIP record of this book is available
on request from the British Library.

ISBN: 978-1-901268-56-0

Printed in China

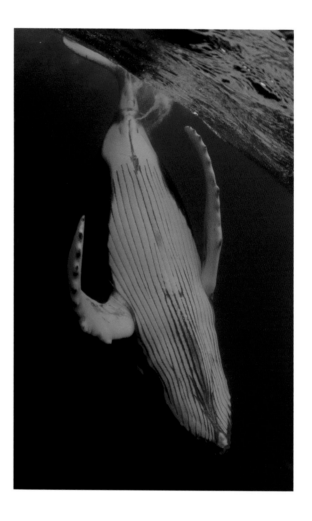

HUMPBACK WHALES

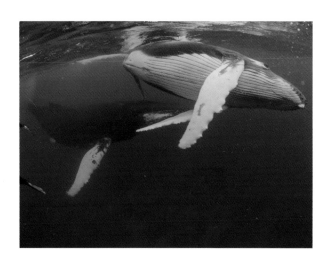

KATE WESTAWAY

Evans Mitchell Books

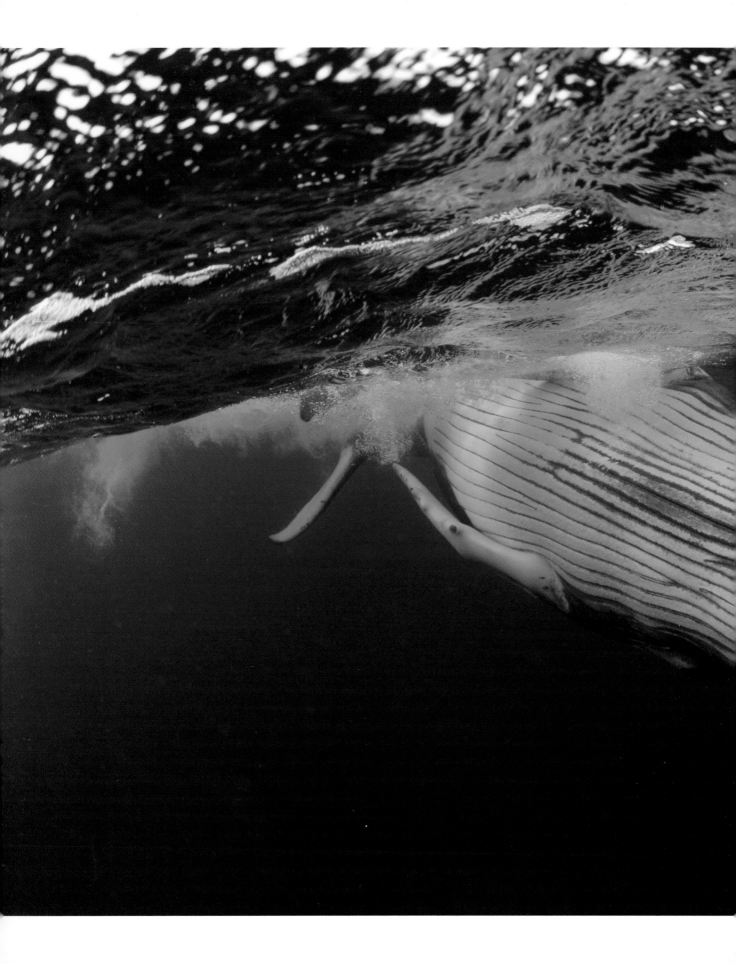

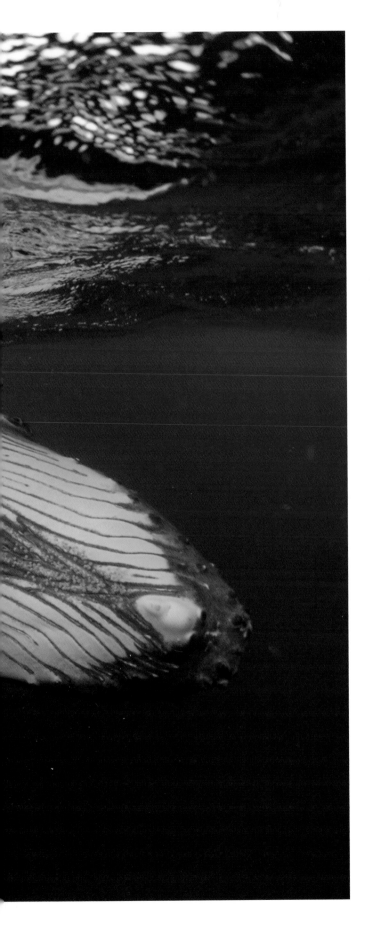

Contents

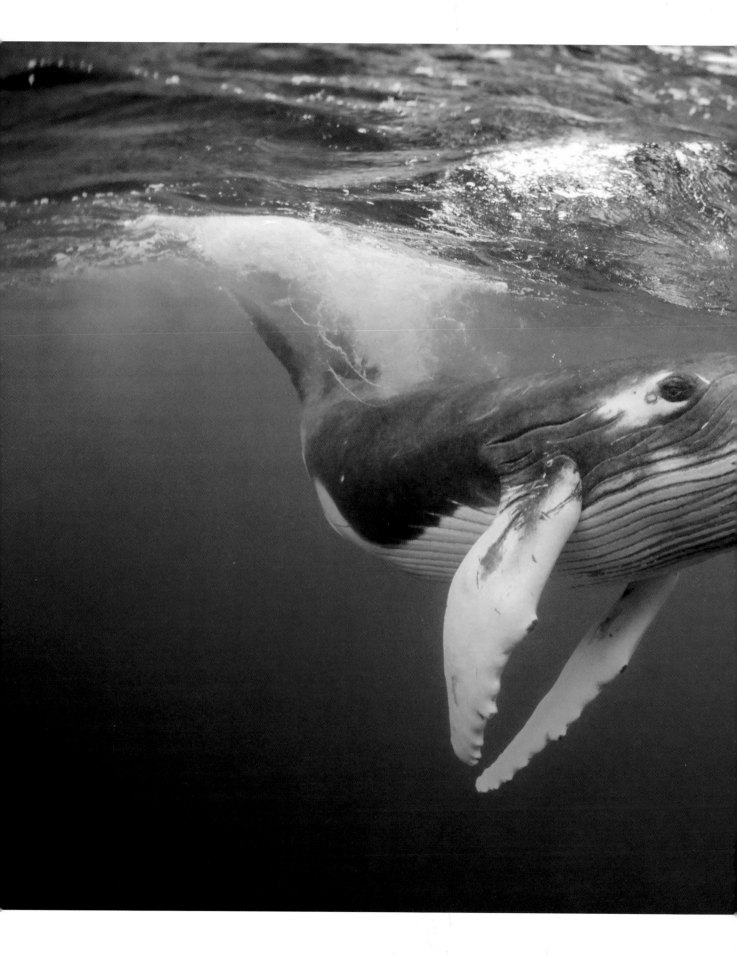

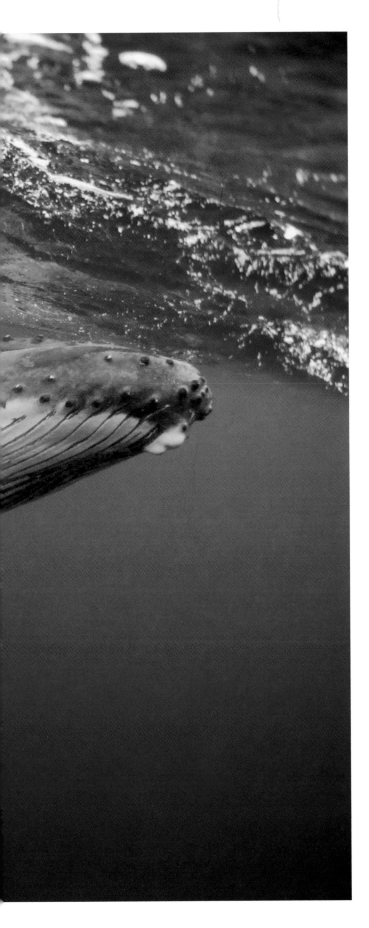

Close Encounters

I have dived with many underwater animals but whales have always held a special fascination for me. This started from a young age; I was spurred on by watching David Attenborough's wildlife documentaries on a Sunday afternoon. I plastered my bedroom walls with whale posters and had a desire to become a marine biologist. I may have ended up a photographer and not a biologist but the passion to have a close encounter with these creatures was still the same.

Their social bonds, their intelligence, their size. I wanted to see how something so huge could move with such grace. I had also been haunted by whale song since I was a little girl, what would it be like to hear this in the sea for real?

I'd heard about whale encounters around the globe and their inquisitiveness of humans and had always wondered – what was in it for the whale?

Left: A giant humpback mother with her distinctive knobbly snout, dives below the surface.

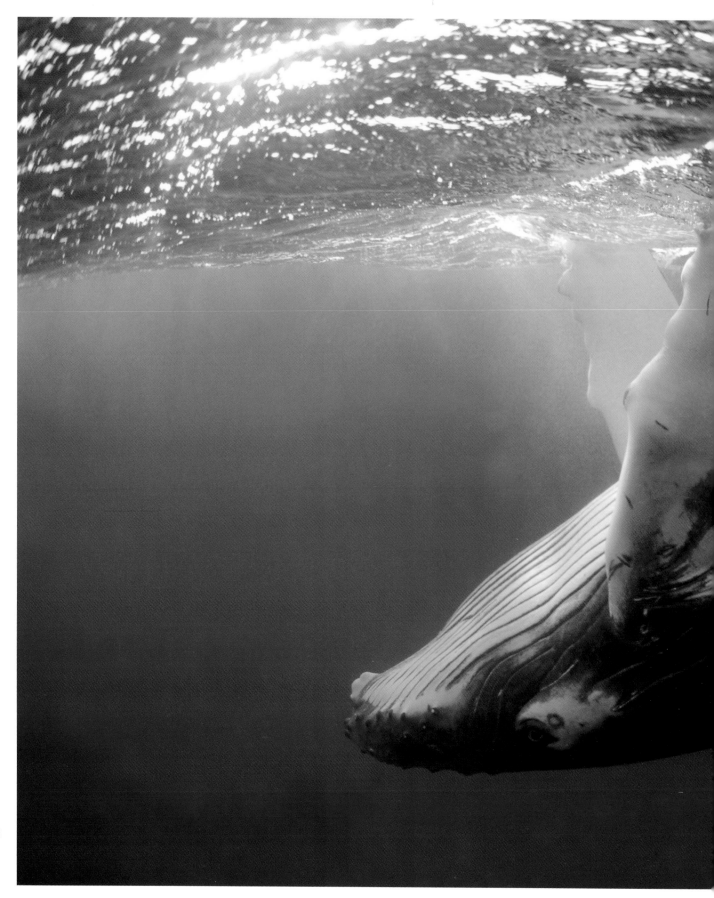

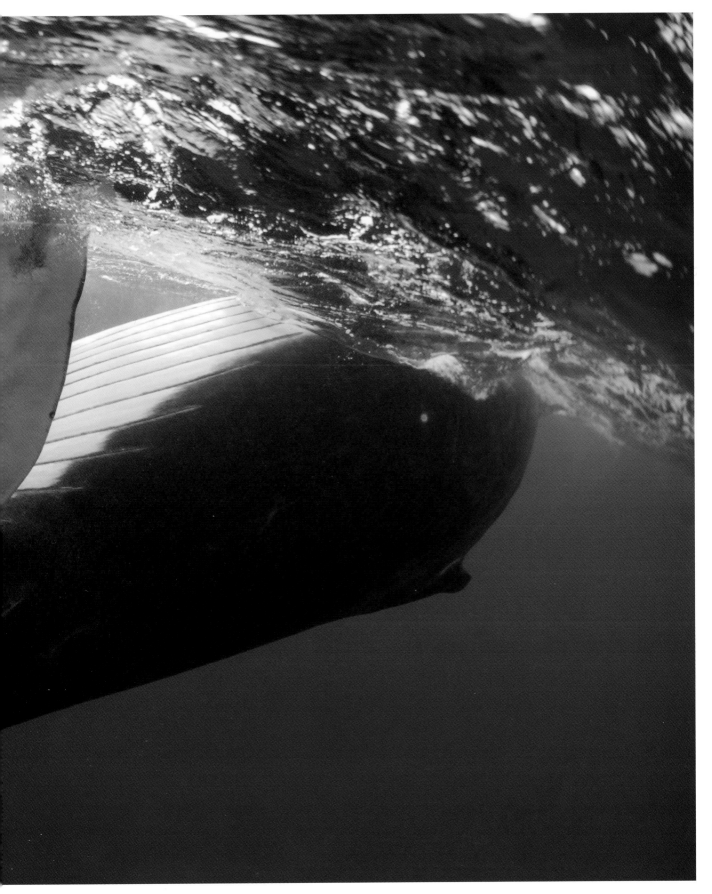

The boat was moored out in the Atlantic over a shallow sandy area, about 10-20m deep and seven square miles, where the humpbacks come annually to mate and give birth and where the young spend their first few months. Every day for a week, eight of us would be led by an experienced crew using a skiff (small powered boat) to track the whales. At the very least we might see them breaching on the surface but really everyone was there to get into the water with them, to experience being with a creature of that size.

There was a nervous anticipation on the boat on the first day. It should be quite daunting being in open ocean in a craft no longer than three metres long but the crew were experts and I was much too focused on the prospect of getting up close to the humpbacks. The excitement subsided slightly giving way to the reality of sitting on a skiff in a wetsuit for hours. I feel the cold easily, which is a bit of an occupational hazard, so I sought out the sunny side of the skiff whenever I could. We were all charged with the task of looking for the whales. When looking out on 360 degrees of choppy open ocean it felt like an impossible task to spot anything. I would concentrate so hard on one spot that I often felt like I was going cross eyed, and I had a tendency to think that the whales were always in the place I was not looking. Then I would impatiently allow my eyes to dart from spot to spot frustrated and uselessly not taking anything in.

I learned that patience was essential for all the scouting trips, which was not easy as I was desperate for that first encounter, to put to rest the doubts that I had that maybe it just wouldn't happen. I was plagued by this thought.

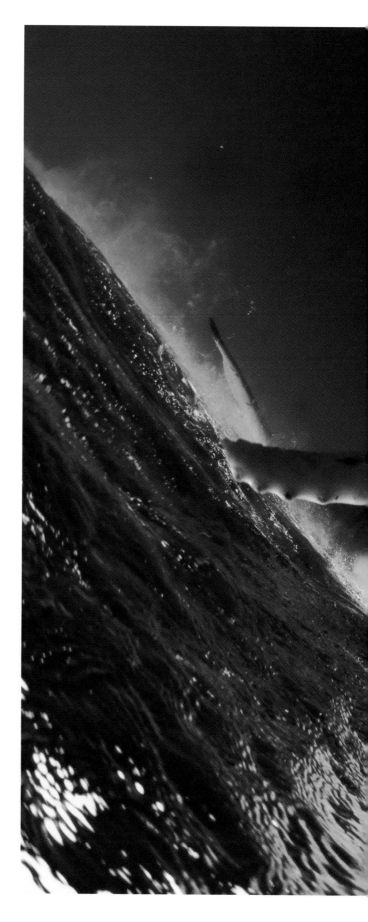

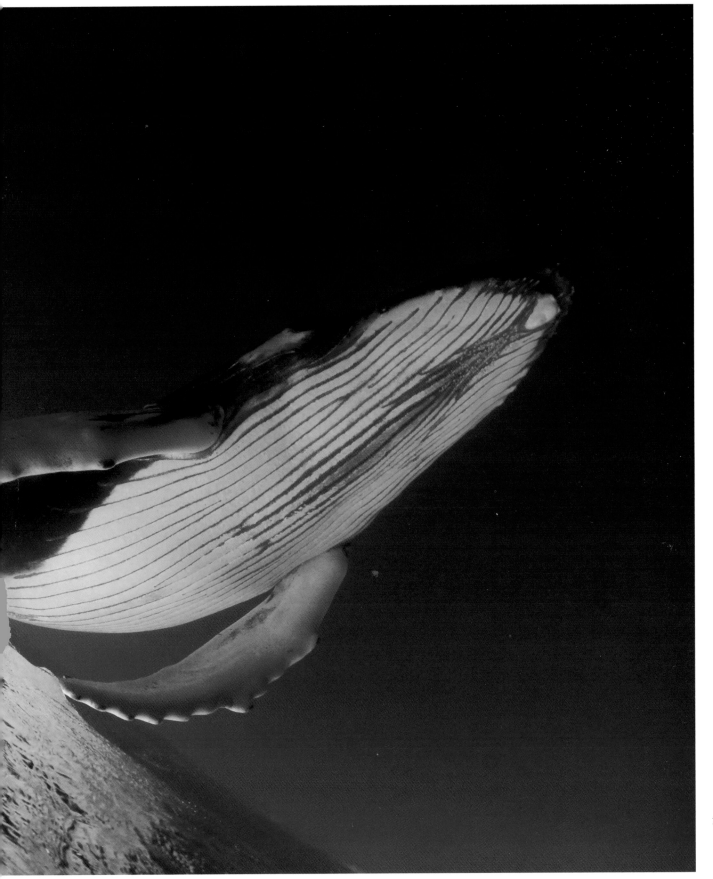

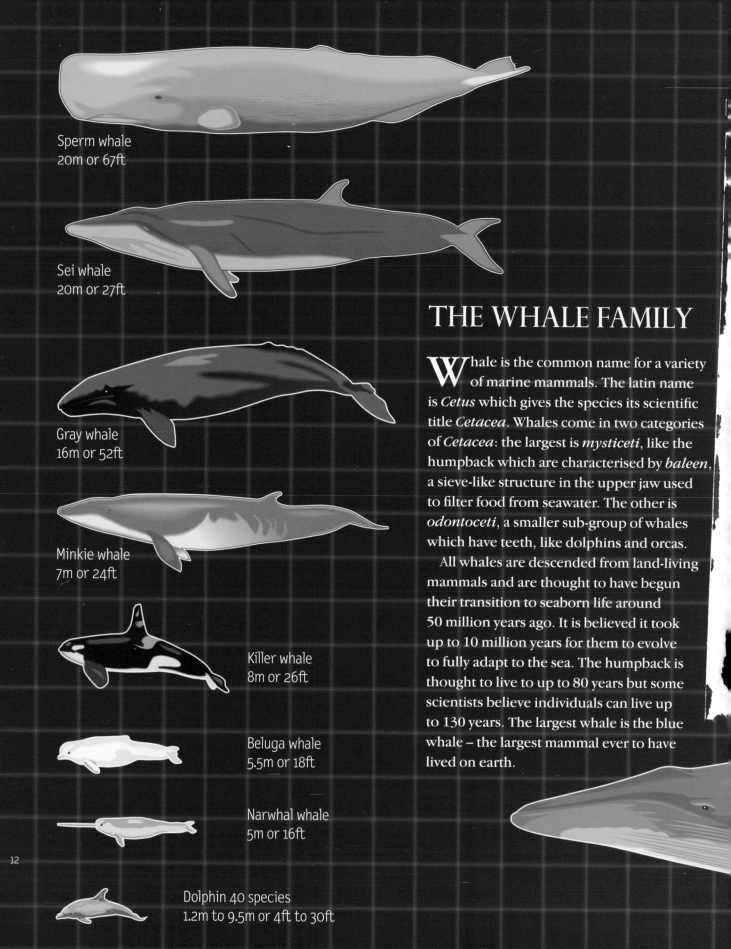

Sperm whale
20m or 67ft

Sei whale
20m or 27ft

Gray whale
16m or 52ft

Minkie whale
7m or 24ft

Killer whale
8m or 26ft

Beluga whale
5.5m or 18ft

Narwhal whale
5m or 16ft

Dolphin 40 species
1.2m to 9.5m or 4ft to 30ft

THE WHALE FAMILY

Whale is the common name for a variety of marine mammals. The latin name is *Cetus* which gives the species its scientific title *Cetacea*. Whales come in two categories of *Cetacea*: the largest is *mysticeti*, like the humpback which are characterised by *baleen*, a sieve-like structure in the upper jaw used to filter food from seawater. The other is *odontoceti*, a smaller sub-group of whales which have teeth, like dolphins and orcas.

All whales are descended from land-living mammals and are thought to have begun their transition to seaborn life around 50 million years ago. It is believed it took up to 10 million years for them to evolve to fully adapt to the sea. The humpback is thought to live to up to 80 years but some scientists believe individuals can live up to 130 years. The largest whale is the blue whale – the largest mammal ever to have lived on earth.

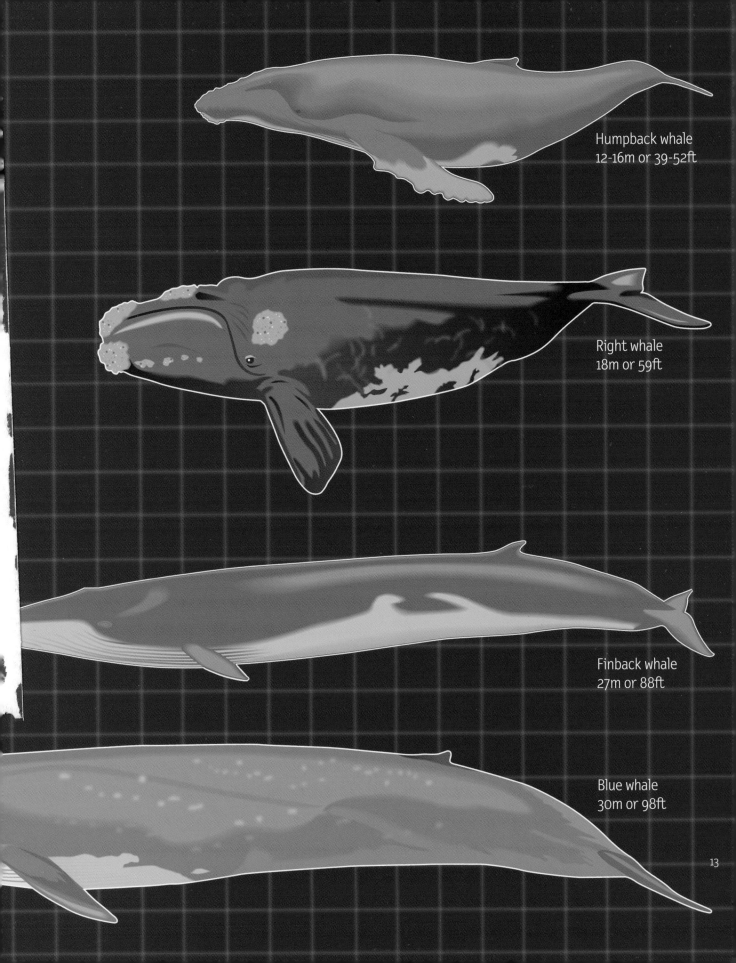

Humpback whale
12-16m or 39-52ft

Right whale
18m or 59ft

Finback whale
27m or 88ft

Blue whale
30m or 98ft

13

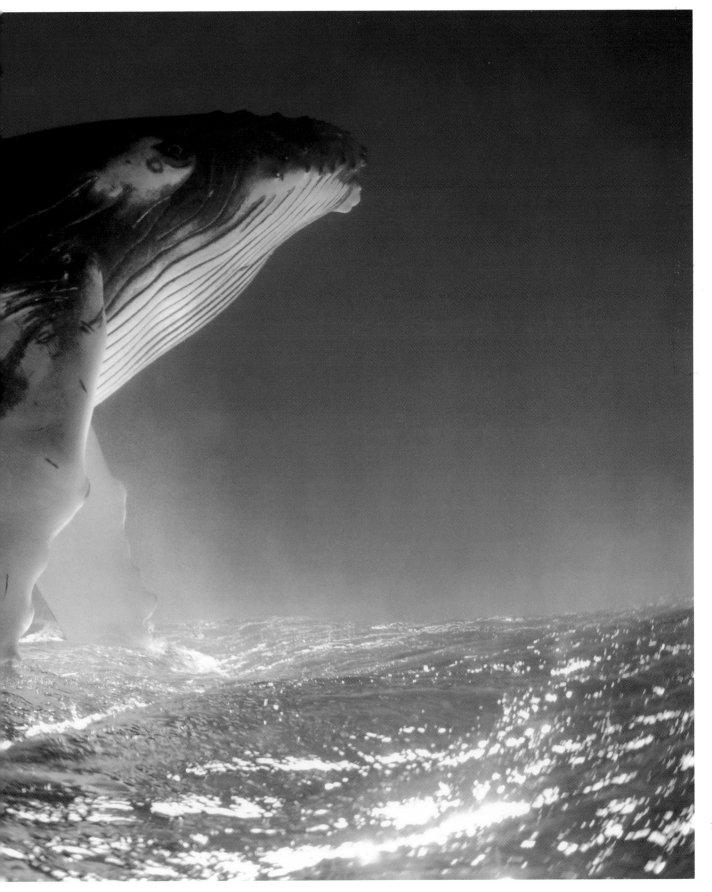

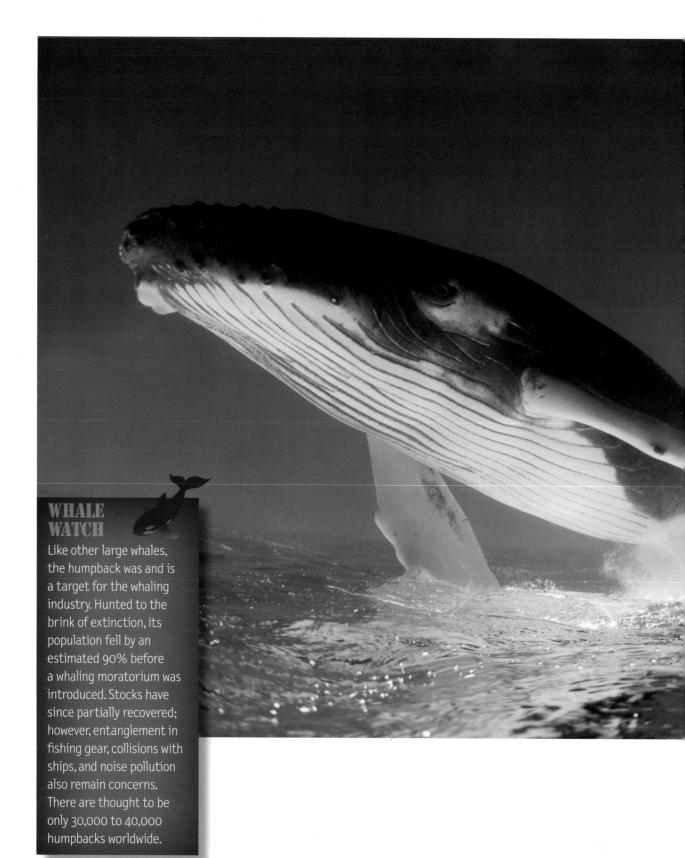

WHALE WATCH

Like other large whales, the humpback was and is a target for the whaling industry. Hunted to the brink of extinction, its population fell by an estimated 90% before a whaling moratorium was introduced. Stocks have since partially recovered; however, entanglement in fishing gear, collisions with ships, and noise pollution also remain concerns. There are thought to be only 30,000 to 40,000 humpbacks worldwide.

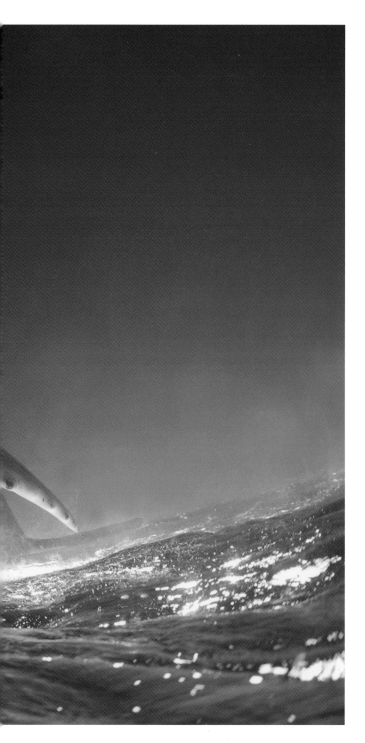

Nature is a cruel mistress and it wouldn't be the first time where an underwater animal encounter hadn't come to fruition for me. There is so much luck and chance involved with having an amazing encounter with a creature like a whale. I know underwater film makers who have spent months on a project waiting for that perfect encounter and the same people have also been lucky enough to film exactly what they want in the first week of an eight week shoot. So I knew there were no guarantees on this, potentially, once in a lifetime trip. The thought that this might be my only chance was never far from my mind.

My mind continued to play tricks on me as I stared out to sea but it was surprising how, after a couple of hours of bobbing up and down I did tune into what was a whale tail and what was a trick of the light, a wave or a total figment of my imagination. We could see that there were whales breaching on the horizon, they were miles away, so we knew there was action somewhere, but just not where we were.

It wasn't until the afternoon that two tails were spotted not far from the boat. We approached slowly and with caution. I held my breath waiting for the verdict. Would they hang around? Or disappear into the blue? "It's two adults." The skipper informed us "and it looks like they are sleeping."

When we were told to get on our fins and mask it was then that I realised I was about to enter the water of my own free will with not one but two adult humpback whales. It really was going to happen and I felt terror. Regardless, I knew that I was so psyched up for this moment that I was going to get into that water no matter what.

17

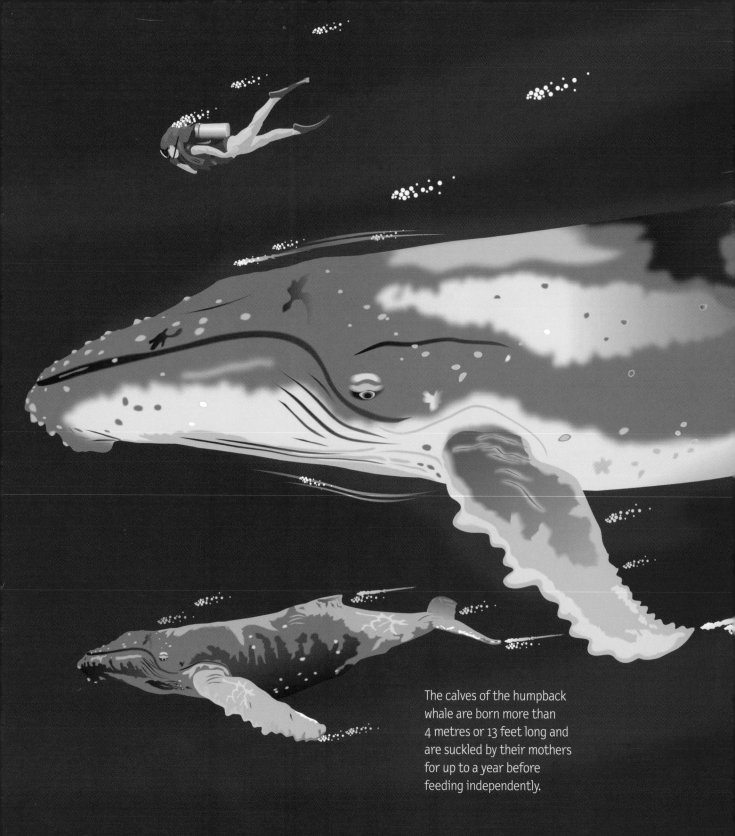

The calves of the humpback whale are born more than 4 metres or 13 feet long and are suckled by their mothers for up to a year before feeding independently.

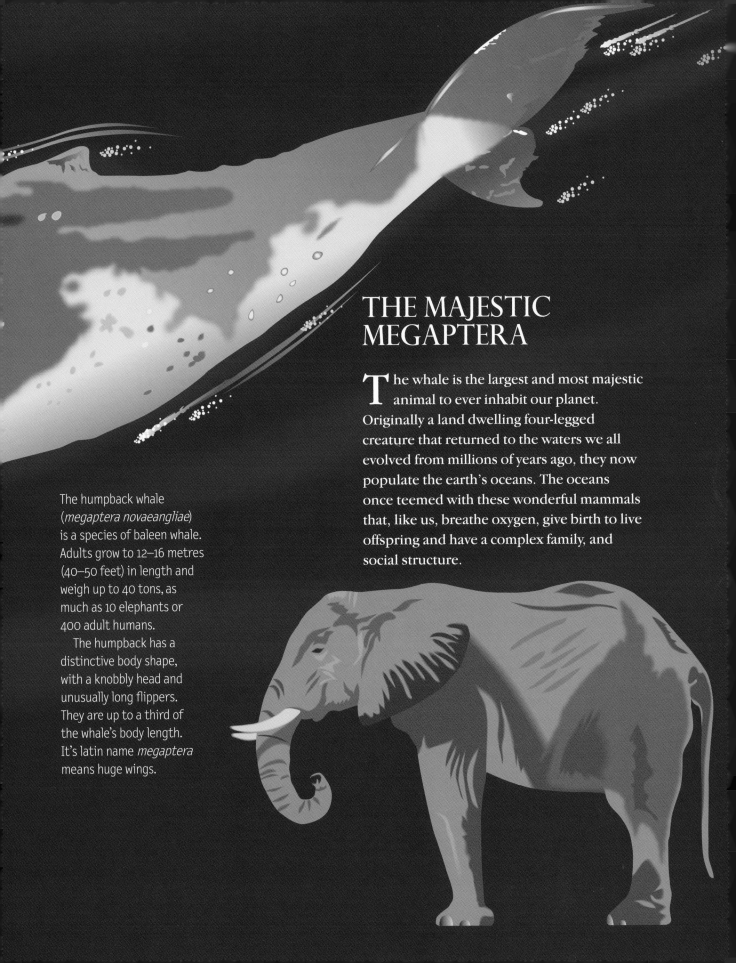

THE MAJESTIC MEGAPTERA

The whale is the largest and most majestic animal to ever inhabit our planet. Originally a land dwelling four-legged creature that returned to the waters we all evolved from millions of years ago, they now populate the earth's oceans. The oceans once teemed with these wonderful mammals that, like us, breathe oxygen, give birth to live offspring and have a complex family, and social structure.

The humpback whale (*megaptera novaeangliae*) is a species of baleen whale. Adults grow to 12–16 metres (40–50 feet) in length and weigh up to 40 tons, as much as 10 elephants or 400 adult humans.

The humpback has a distinctive body shape, with a knobbly head and unusually long flippers. They are up to a third of the whale's body length. It's latin name *megaptera* means huge wings.

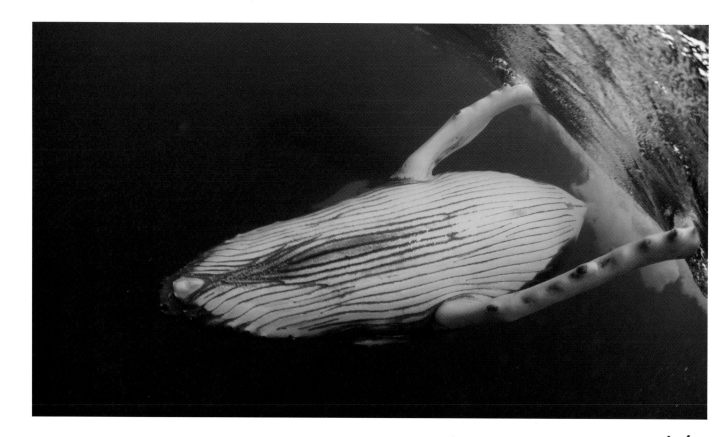

Sliding into the open ocean I consoled myself with the fact that I was not alone. The current was running strong against us and it was a battle to swim towards where we were told the whales were. The visibility was very poor which made the experience all the more creepy.

The whales were less than 10 metres away but we couldn't see them, I could just make out the sandy bottom with the sunlight playing on it. The choppiness of the waves meant that I swallowed sea water down my snorkel, partly because in my haste to get in the water I'd pointed the air intake the wrong way. Choking and spluttering whilst struggling to keep up with the group was not how I had imagined this moment would be.

WHALE WATCH

Humpbacks come in four different colours, ranging from white to gray to black to mottled. Distinctive patches of white on the underside of the flukes (tail) are unique to each individual whale, and, like a fingerprint are used to identify individuals by whale researchers. The humpback's skin is frequently scarred and may have patches covered with barnacles.

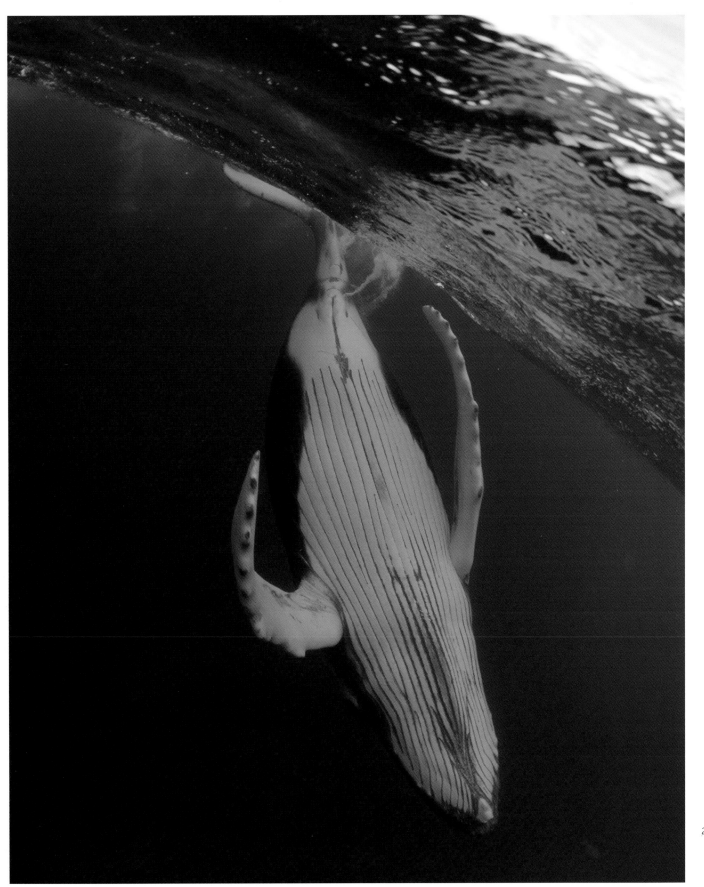

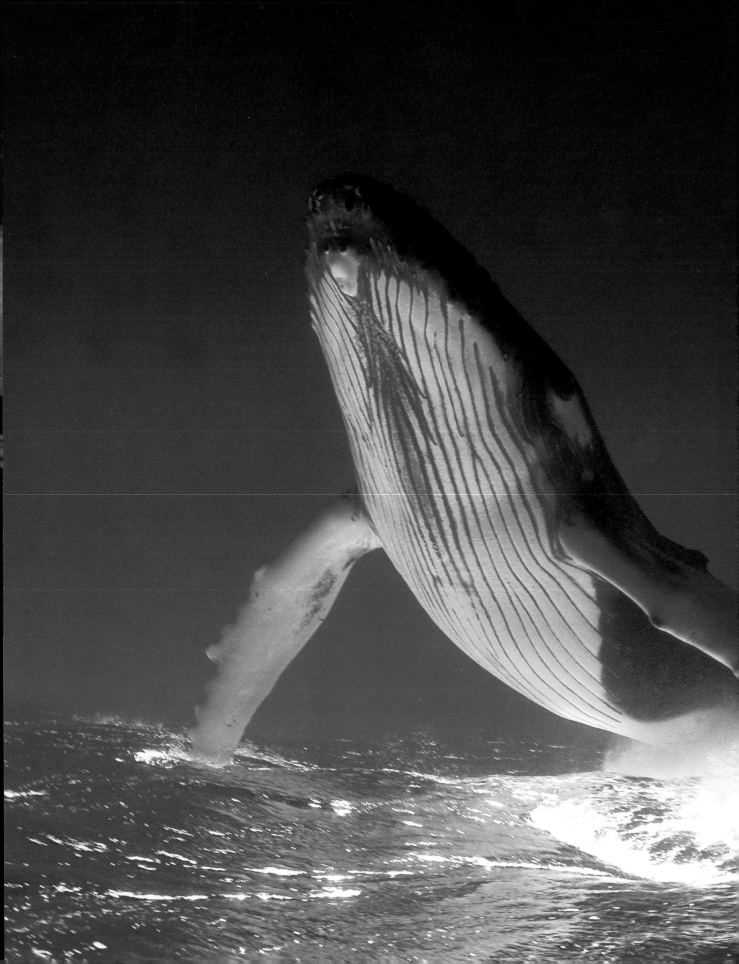

I snorkelled furiously against the current, my heart pounding and my leg muscles aching as I paddled with one arm and dragged my camera along with the other (the non hydro-dynamic nature of my camera was certainly against me in the speed stakes). I continually scanned the murky depths below me, straining my eyes to see something.

And then I could make out a dark shape, my heart stopped, it was enormous and I wasn't even above it. I kept finning, and a second dark shape appeared. Totally still.

There they were sleeping, suspended in the gloomy water just off the bottom a male and a female. My experiences as a diver and photographer felt irrelevant and it was more terrifying than I had expected to float above the enormous shadows 10 metres below me.

WHALE WATCH

There is only one humpback whale population that doesn't migrate. It inhabits the waters of the Arabian Sea. It doesn't have to migrate for food because the monsoon brings nutritions from the sea floor to the surface which create a foodchain, by encouraging algae growth which in turn attracts the humpback's food sources like small shrimps and fish. So the whales stay in these tropical waters year round.

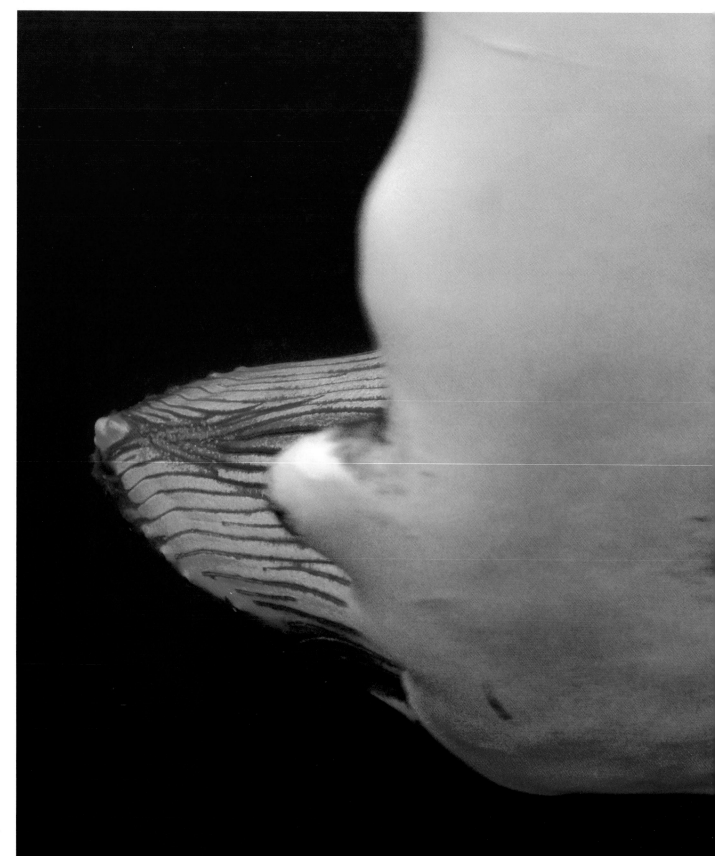

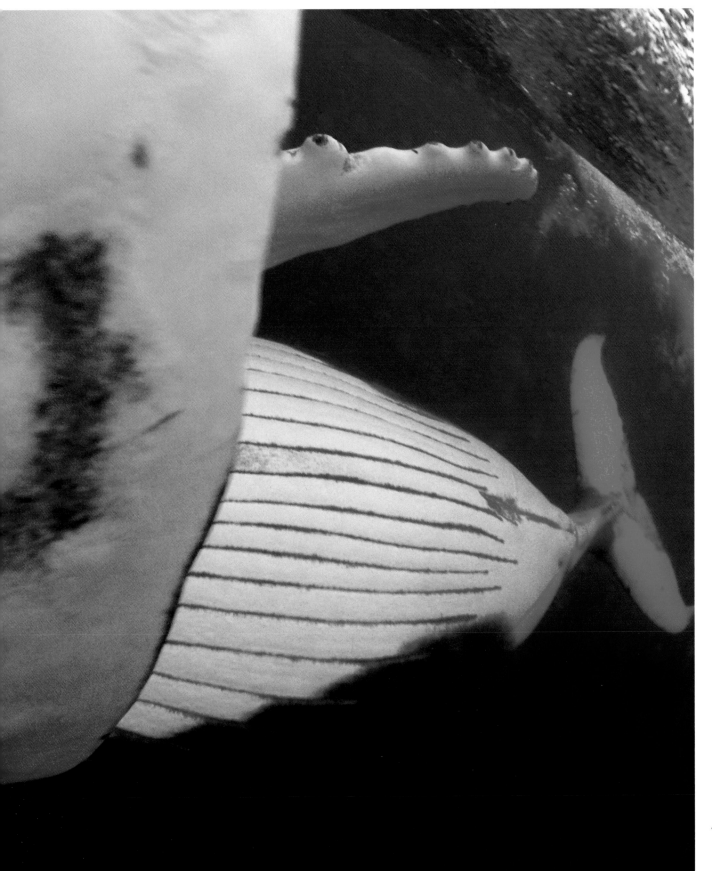

WHALING: for science experiments and food.

SURFACE COLLISION: Many whales washed up on beaches have been found to be fatally injured by ship's propellors while living whales have been observed to be deeply scarred.

NAVAL SONAR: some scientists say sonar is killing many whales, not only causing beachings but also damaging internal organs with destructive sound waves.

THE MENACE OF MANKIND

In the last two hundred years whale populations have faced increasing threats from mankind's desire to harvest the ocean's natural resources. From the factory whaling ships that hunted some whales to the point of extinction (which lead to an international moratorium), to exploration for oil and gas.

Even submarines are considered a threat to our sea mammals. Underwater collisions are not unknown and scientists believe submarine and surface vessel sonar is also causing whale deaths.

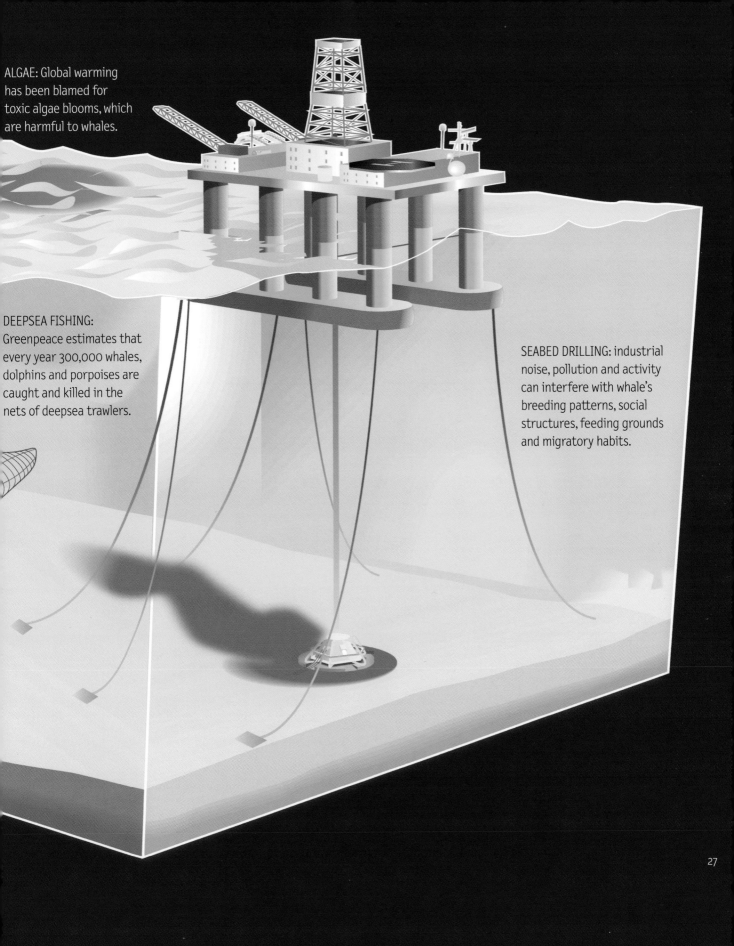

ALGAE: Global warming has been blamed for toxic algae blooms, which are harmful to whales.

DEEPSEA FISHING: Greenpeace estimates that every year 300,000 whales, dolphins and porpoises are caught and killed in the nets of deepsea trawlers.

SEABED DRILLING: industrial noise, pollution and activity can interfere with whale's breeding patterns, social structures, feeding grounds and migratory habits.

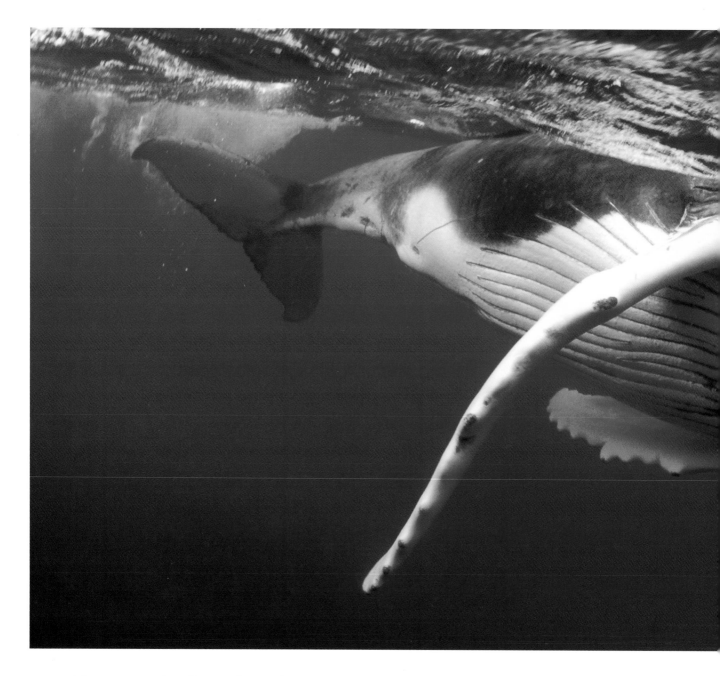

They were eerily still. I was finning hard above them to stay put when they both began to move slowly forward. Suddenly I wanted to be anywhere but directly above a whale coming up to take a breath, I let the current carry me back and out of the way just as he broke the surface.

Their movements were so graceful yet deliberate that I wondered if they weren't real at all but mechanical beings controlled by the captain of our boat, to put on a show for the paying punters. It was strange that something so perfect looked false.

And then I heard it at last. Whale song. I expected it to be frightening and loud but it was neither, it was gentle, soothing and non-threatening. And then came the response. I felt like I had Dolby Digital Surround Sound whale

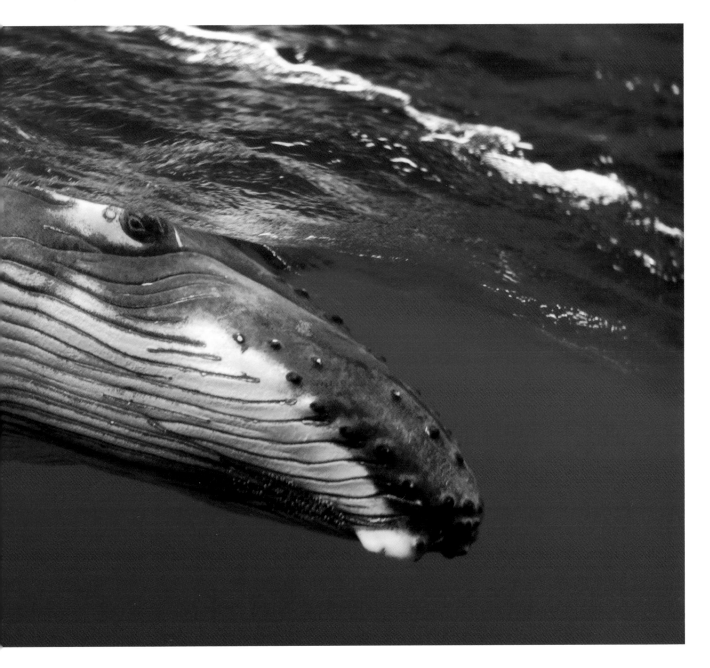

song. It has been described, as the most complex in the animal kingdom and it's easy to forget that the songs are actually for communication.

It is hard not to resort to cliché when talking about whale song, for so long it provided the soundtrack for shops selling joss sticks and candles and was mocked for its associations with 'alternative' therapies and use on relaxation tapes. Hearing it for real is haunting, ethereal and transporting. I never saw the whales that created the whale song (they can be many miles away as the sound travels miles underwater) which means I always heard it whilst floating in an eerily empty ocean as far as my eyes could see, the sheer distances that this song can travel adds another dimension to listening to whale song for real.

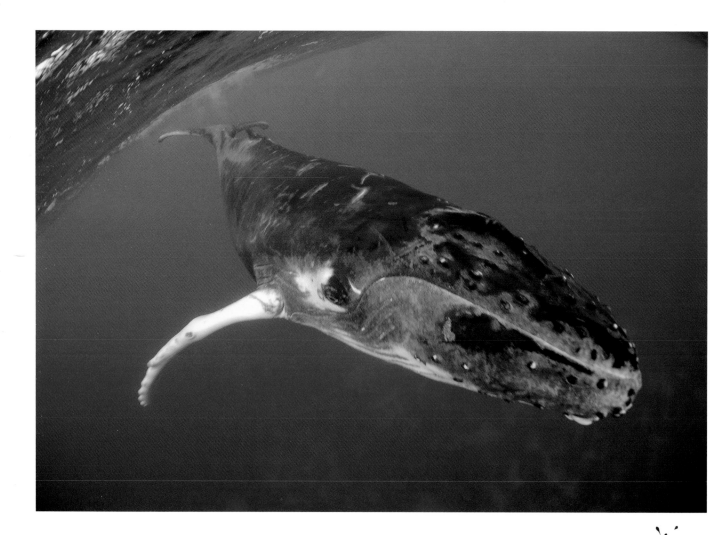

It is also about more than just the beauty of the song. When you are underwater you hear both sides of the "conversation" in real time. It is a million miles from the tape recordings in the joss stick shop, something taken for granted on dry land is so far from the reality of listening to it in the flesh. It stirred up something guttural, instinctive and primitive, like listening to something lost in time yet strangely familiar.

Taking photographs was not at the forefront of my mind. My shock and awe at the two baleens and the whale song proved too much of a distraction. They were too far below for a decent shot and the poor visibility gave me huge focusing problems. I did take a few shots when they came to the surface, the scene was surreal,

WHALE WATCH

Whales lose body heat up to 25 times faster than man. So why don't they freeze in cold water? Whales have up to 50cm of thick fat under their skin which is called blubber. This layer increases the distance between the water and the body cavity thus insulating the organs and preventing heat loss — like layers of big thick blankets.

WHALE WATCH

Humpback whales do not sleep as humans do. They need to be conscious to be able to breathe. Therefore, they have adapted the ability to shut down half of their brains at a time to enable rest. In doing so they are still aware of their surroundings in terms of predators and other dangers, but they are able to rest. Whales have been observed in this state for up to eight hours a day.

a 40 ton creature suspended mid-water but I wasn't able to capture it; this encounter was not for the memory card rather one for the memory bank.

The next few days were exciting for topside observations but not so great for in-water encounters, plus the wind was picking up and we had to sit a couple of mornings and an afternoon out as it was too dangerous for the skiff. Nature, again, was the dictator of my photographic destiny. Frustrated, I tried to read but kept checking to see if the wind had dropped… every five minutes… like a child in the back seat waiting desperately to arrive at the destination. Except my mental mantra was, has it dropped yet? Has it dropped yet? Has it dropped yet? It hadn't. It didn't.

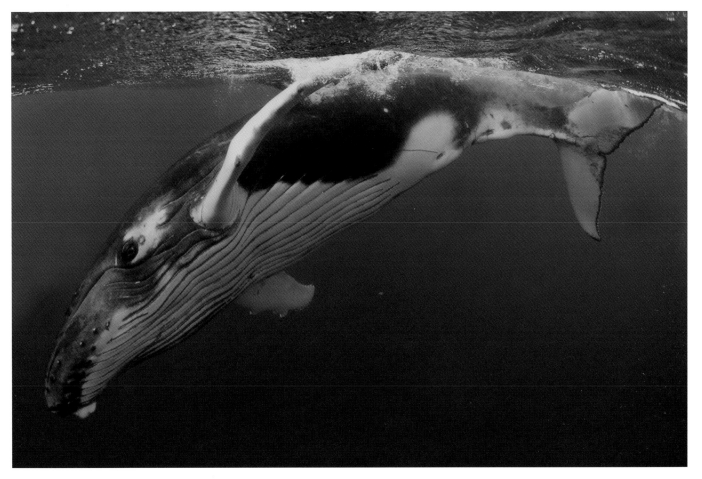

On the fourth morning the wind had dropped, the sea was calm and I had a surge of optimism. Today was the day, I had a feeling.

Sure enough when we sped out on the skiff we spotted a mother and calf nearby, the calf was breaching and seemed playful. I had been worrying about the difficulties of focusing with the poor visibility and had already decided that the way forward was to manually set my camera focus to infinity and leave it there.

WHALE WATCH

Humpback whales are usually up to 15m long (females are bigger than males). Calves are over four metres long when born and start feeding independently after about six months although they can suckle for a year. Humpback's usually give birth to one calf every two to three years.

For mating and calving humpbacks swim to tropical and subtropical latitudes in the winter to reach their breeding grounds. After breeding season, as summer approaches, the humpback whales swim to polar waters which contain abundant food. Humpback whales can travel many thousands of kilometers a year.

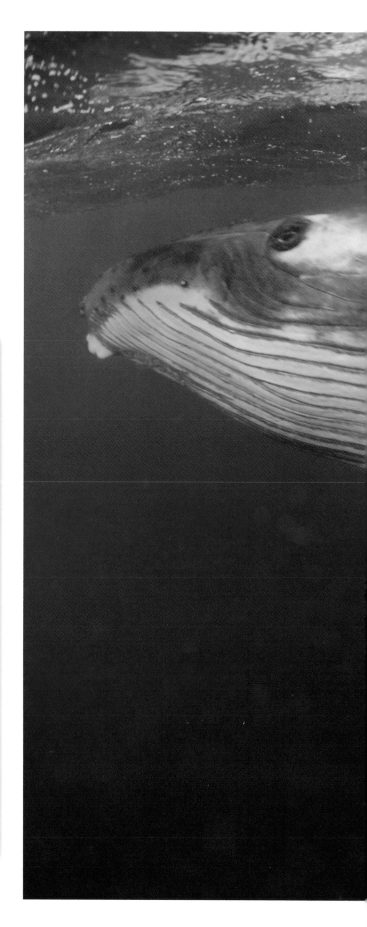

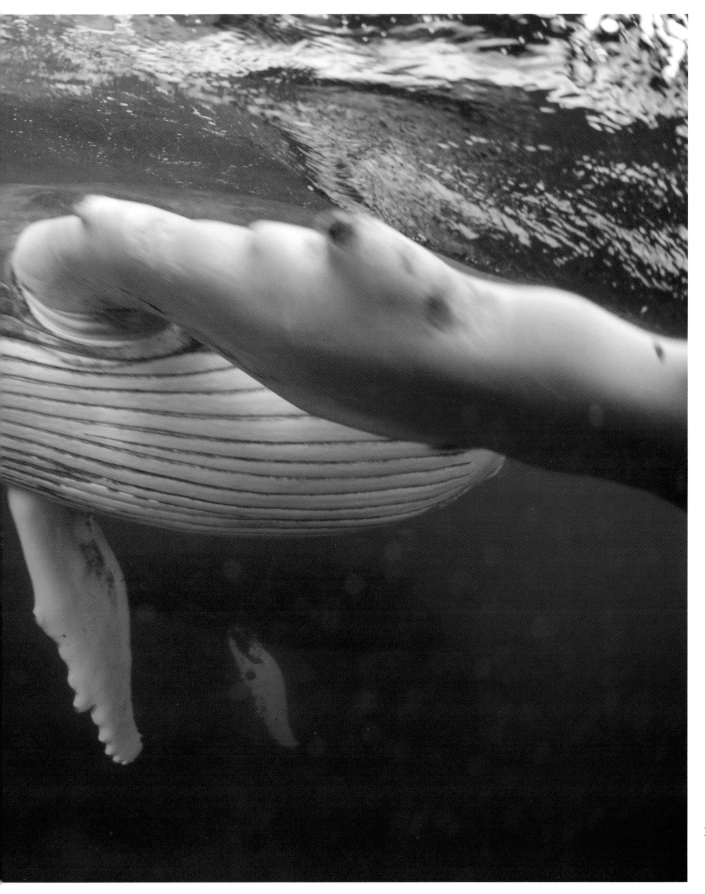

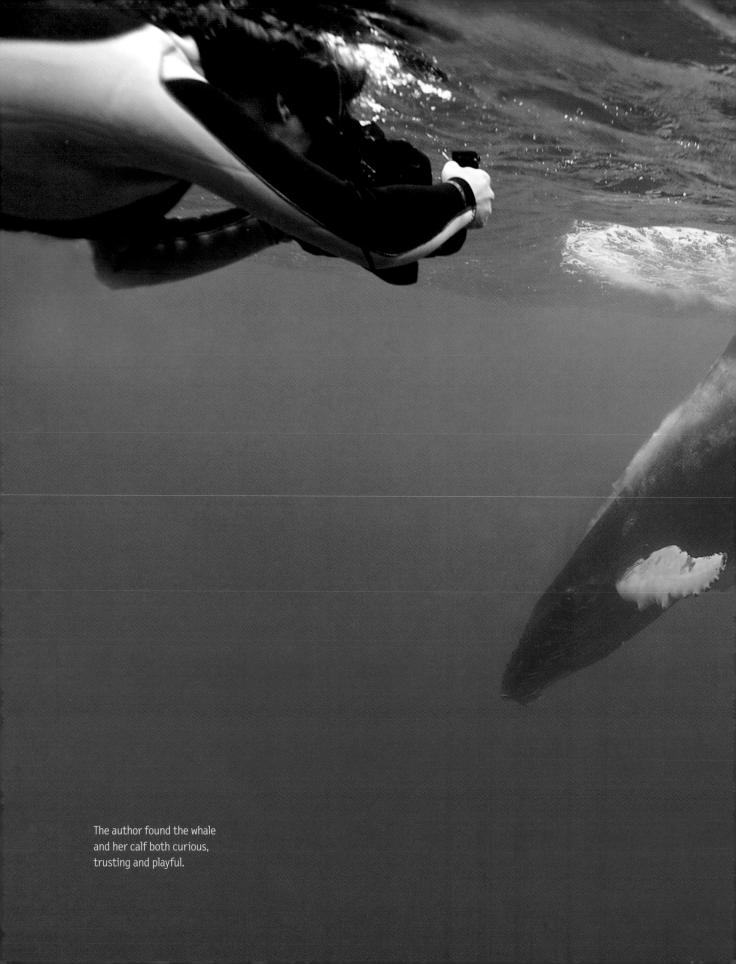

The author found the whale
and her calf both curious,
trusting and playful.

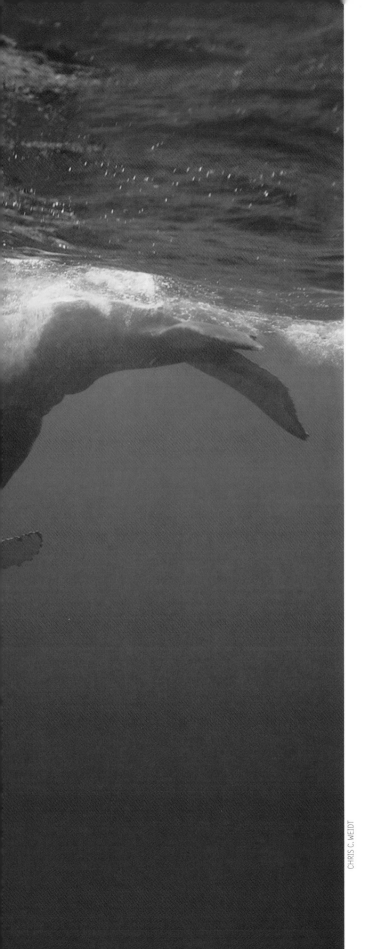

This meant that the focus would stay in one place. I slipped into the water for my second encounter, the desire to get some decent shots had helped my courage to grow. Off I snorkelled towards the somewhat distant shadows. I wasn't sure that I could reach them but it wasn't long before the calf turned and swam straight towards our small group. He felt distant but with no hesitation this time, I clicked away, twisting and turning trying to keep up with his movements. And then he was gone. It was over. No shadows, just the light trying to penetrate the gloomy water.

It was brief but it didn't matter, I had been elevated to a level of excitement that I didn't know existed, apparently shared by the rest of the group.

Back in the boat we all talked over the top of each other, shivering and comparing notes. I checked back my shots, I knew they looked good when I was down there. In the cold light of topside they didn't look sharp. I knew it immediately but I was willing them to be sharp, how could they not be in focus? How could my once in a lifetime chance of photographing something that I had dreamed about all my life, not be in focus? It just wasn't possible. I showed it to the skipper, " They're not in focus" he said.

I died right then on that boat. I'd blown my one chance, how often did encounters like this happen? And for it to be my fault, for once I couldn't blame my old adversary nature. I'd made a mistake by choosing to set my camera to infinity and it was unforgiveable. Ten years of underwater photography experience and I'd made a schoolgirl error right at the point when it really mattered.

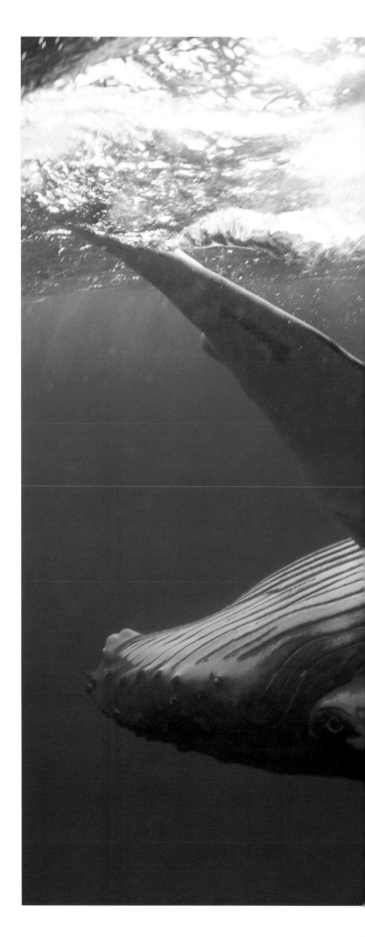

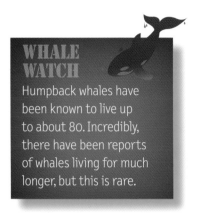
With everyone else still buzzing from the encounter, my mood plummeted, made worse by the belief that the pictures were great. And it all happened so fast. The encounter, the best moment and then one of the worst moments of my life.

The wind started to pick up. We had to head in, no more whale watching for that day, the penultimate for the trip.

Back on board I tried, desperately, to be positive. That I'd had an amazing encounter that would stay with me forever. I tried not to sulk or to be sad, there was always tomorrow.

I woke up on the last full day of the trip being rocked back and forth in my cabin. Hmmm, that wasn't a good sign. I stepped out on deck and there were white horses all the way to the horizon. The captain said it was a 35 knot wind (we could only take the skiffs out in 25 knots or less).

So it was the last day, I had no decent pictures, just some disasters of the calf that were out of focus and quite a lot of big dark shadows, that begged the question was it a whale or was it a rock? National Geographic weren't going to be on the phone when I got home. My optimism was being tested to the limit.

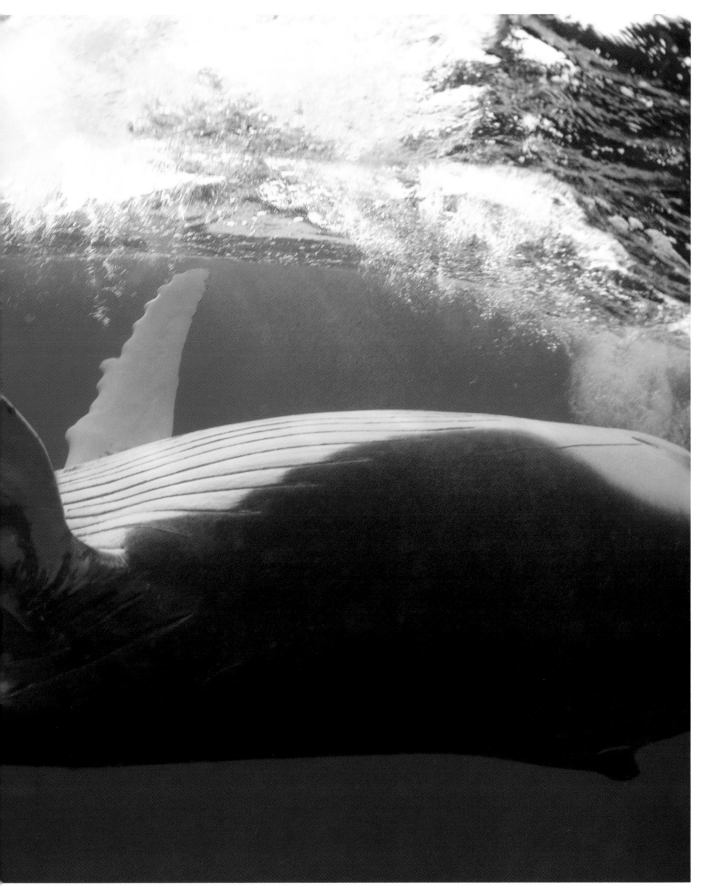

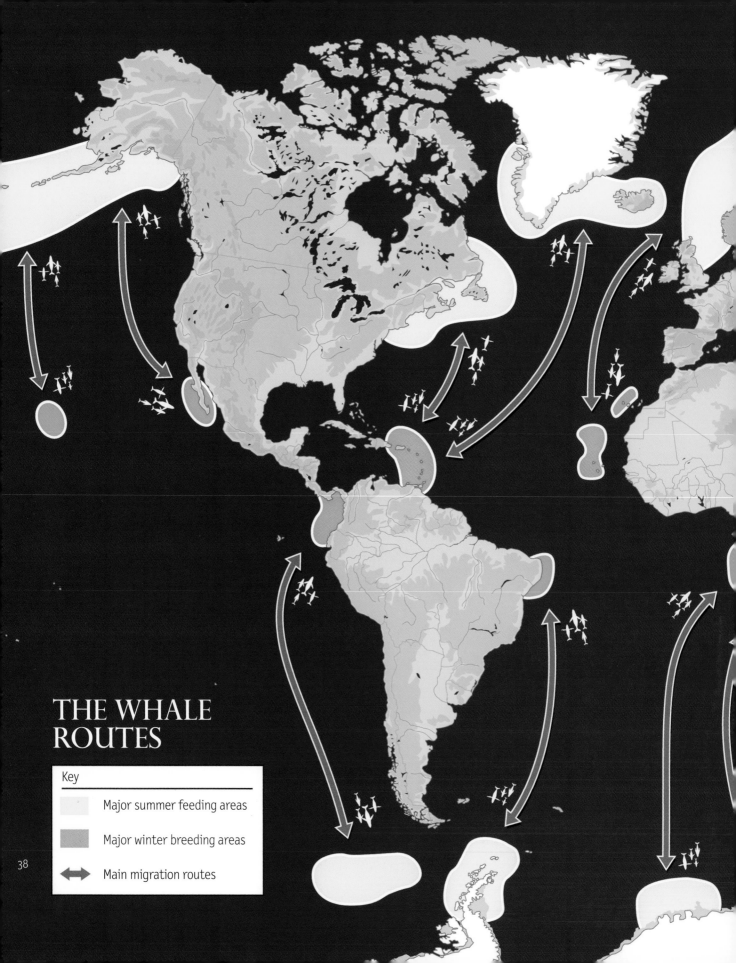

THE WHALE
ROUTES

Key

Major summer feeding areas	
Major winter breeding areas	
←→	Main migration routes

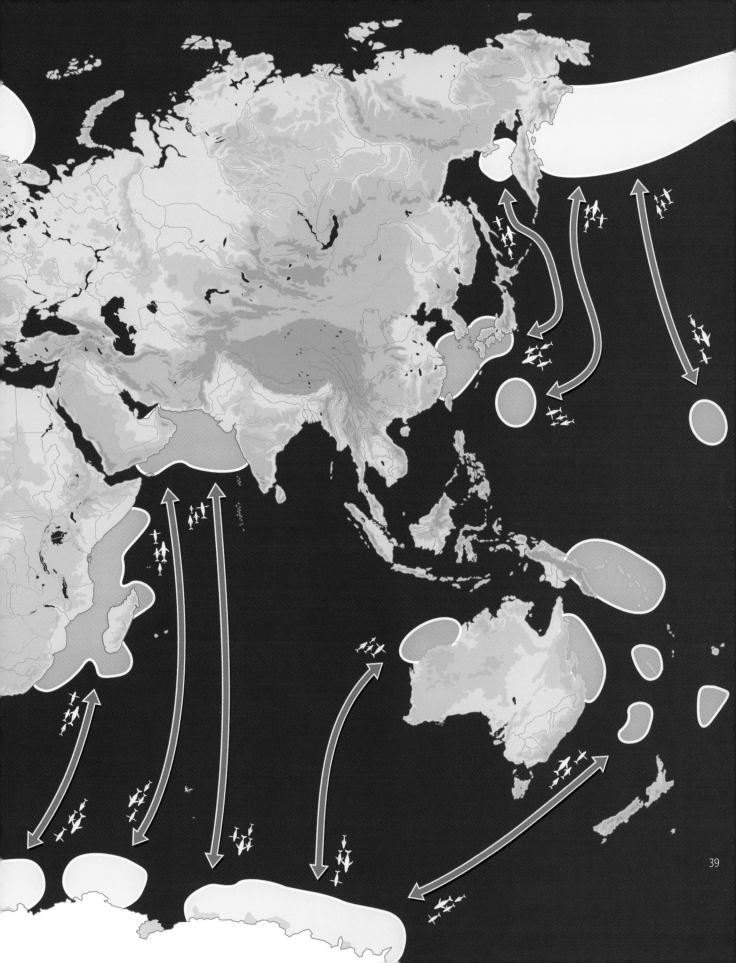

WHALE DISPLAYS

Whales are social creatures and have become known by humans for their acrobatic displays as they leap out of the water, exposing their bodies to avid whale watchers. Whales have several distinct types of activity that prove to be most impressive when executed in their powerfully majestic form.

INTO THE BREACH

When the whale breaches, it lunges out of the water, exposing at least 40% of its body. A leap exposing less of the body is referred to as being a lunge, and is not intended to actually clear the water, but rather just as the result of a fast, upwards swim. Breaching is done with the clear intention of getting out of the water, and for various reasons. Some whales breach by swimming directly towards the surface of the water from deep below, rising nearly perpendicular to its surface and tipping over almost immediately. Other species coast along just under the surface of the water and suddenly jerk upwards and out of the ocean. A typical breach will be at about 30 degrees to the water's surface. A successful breach will actually expose up to 90% of the body. For a humpback whale to achieve this sort of display, it must be travelling at approximately 29km per hour.

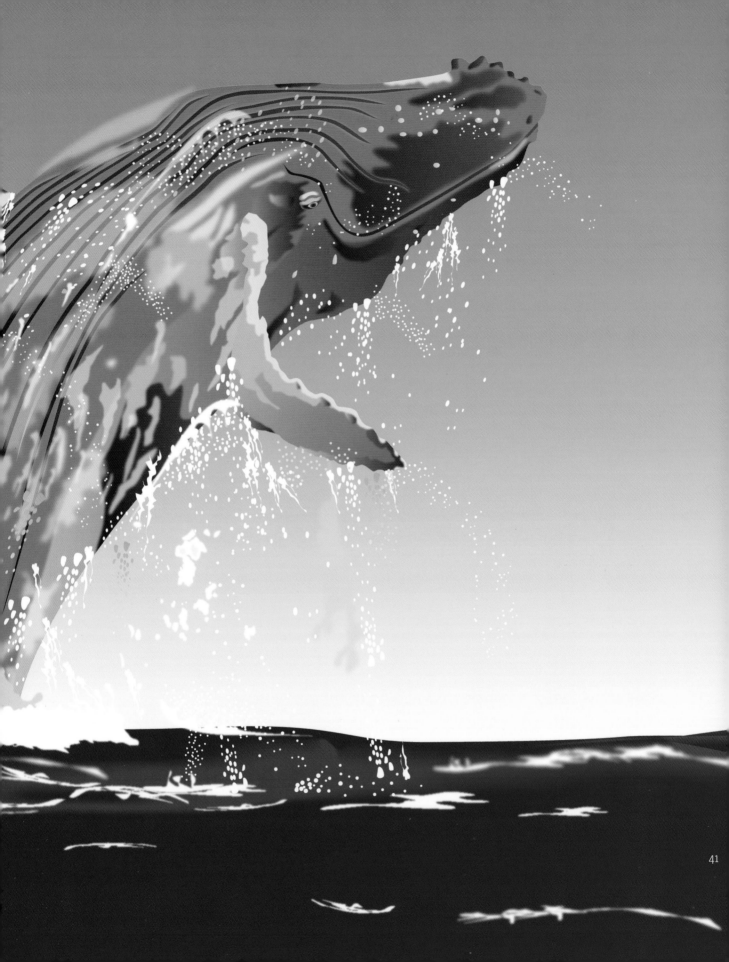

A LINGERING LOOK

Whales breach for various reasons. They tend to breach when they are in groups, implying that it has social relevance and can be a way of establishing dominance and impressing their peers. Breaching can also be performed to impress a prospective mate and during courtship. It may be used as a distress signal. Whales use up a lot of their precious energy resources in performing these powerful jumps, so fellow whales take this breaching very seriously and are likely to respond appropriately.

Some research has indicated that whales may also breach to cause the loud splash, stunning and scaring their prey, and that whales even use this as a way of ridding their skin of parasites.

SPYHOPPING

The act of spyhopping involved less of the body being exposed than breaching (usually only up to about 50%).

It is also differentiated from breaching by the fact that the whale will hold its position out of the water for a period. This serves similar purposes to those of breaching, but also allows the animal to get an idea of its surroundings. An orca is likely to spyhop in order to spot prey, such as seals.

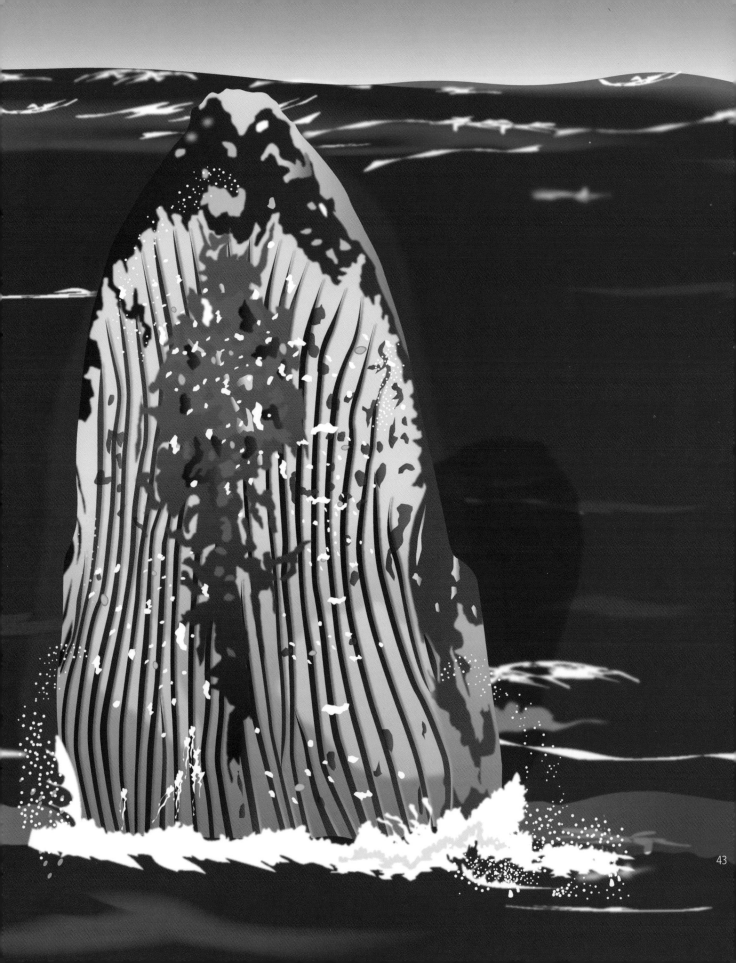

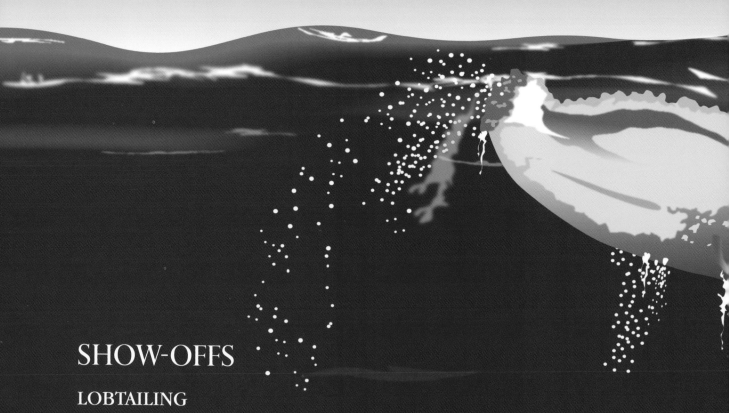

SHOW-OFFS

LOBTAILING

Whales are known for slapping their tails, or flukes, onto the surface of the ocean, creating a splash. Even species with large flippers have been seen using them to create these heavy slaps and splashes. Interestingly, lobtailing is more common in species that have more complex social structures than those that do not. When preparing to lobtail, the whale will position its body downwards vertically and bend the tail stock, allowing for a strong, fast slap. One session of lobtailing will consist of several slaps, rarely just one. While lobtailing can be heard by other whales and dolphins hundreds of metres away, it is still not as effective as their other vocal means of communication and is thus likely reserved for showing off and as a sign of aggression.

There has also been a theory that this splashing noise scares fish and causes them to stick closer together, providing the hunting whale with a larger number of fish in a smaller area.

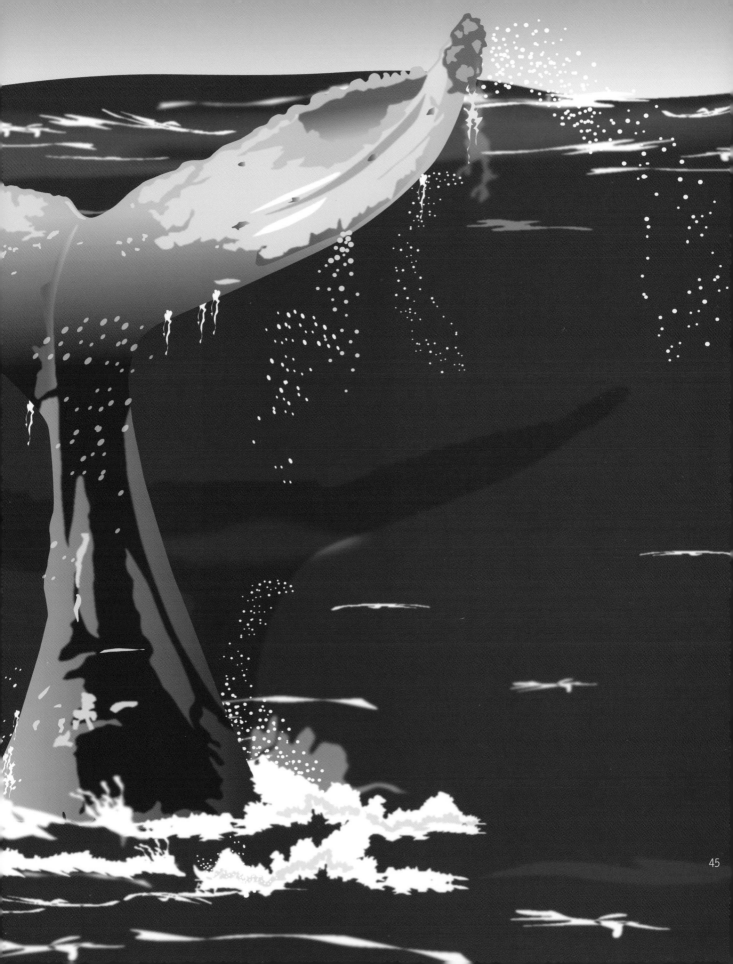

SONG OF THE SEA

Both male and female humpback whales vocalize, however only males produce the long, complex "songs" for which the species is famous. Each song consists of several sounds that vary in volume and frequency, and typically lasts from 10 to 20 minutes. Humpbacks may sing continuously for more than 24 hours. They have no vocal chords, so whales generate their song by forcing air through their massive nasal cavities.

song. Why only males sing, is an enigma although it is thought the primary purpose is to flirt with and attract females. Yet many of the whales observed to approach a singer are other males, which can result in conflict. Singing may therefore be a challenge to other males.

Some scientists suggest that the song may serve an echolocation function, like an underwater radar. During the feeding season, humpbacks make altogether

The males perform while deep below the surface. The haunting, resonating music consists of a series of low frequency moans, whistles, and rumblings which may be repeated dozens of times over several hours. These song patterns can change gradually over time, so that new songs emerge every few years.

Whales within a large area sing the same song. All North Atlantic humpbacks sing the same song, and those of the North Pacific sing a different song. Each population's song changes slowly over a period of years without repeating.

Scientists are unsure of the purpose of whale

different "songs" for herding fish, and it may also serve as a general communication between individuals.

Humpback whales have also been found to make a range of other social sounds to communicate such as "grunts", "groans", "thwops", "snorts" and "barks" and clicks.

The short clicking noises whales produce bounces off external sources to form a clear picture of the obstacles which lie in their path. These short noises of one to five seconds long are a highly effective sonar system for the whales. Sound travels over four times as fast in water than it does on land, making whale

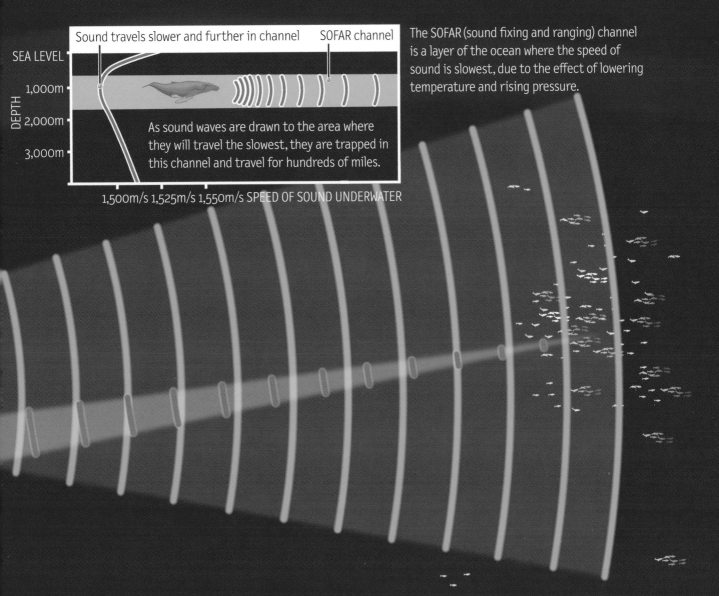

Sound travels slower and further in channel SOFAR channel

SEA LEVEL

1,000m

DEPTH

2,000m

3,000m

The SOFAR (sound fixing and ranging) channel is a layer of the ocean where the speed of sound is slowest, due to the effect of lowering temperature and rising pressure.

As sound waves are drawn to the area where they will travel the slowest, they are trapped in this channel and travel for hundreds of miles.

1,500m/s 1,525m/s 1,550m/s SPEED OF SOUND UNDERWATER

communication far quicker than human communication.

Once the echo from the whale's sound has bounced off an object and returns to the whale, it is received by the lower jaw. From here, sound is transmitted through a continuous body of fat to the inner ear. If the object is very close to the whale, the sound will be returned with less interference and will be much louder. To compensate, the whale will lower the sound of its emissions as it approaches the object.

When it receives an unusual echo back, it is then able to intensify its sonar emission in order to gauge the size and distance of that particular object. This

ability has aptly been dubbed "seeing with your ears", a unique ability which enables whales to be efficient hunters and intelligent mammals of the ocean.

Marine creatures are largely dependent on sound for communication and sensation, as their other senses are limited due to their watery habitat. Environmentalists appear to be concerned about whales being harmed and not being able to find mates because of the increased noise levels at sea caused by ships and other sources. The humpback whale songs for instance are often disrupted and this causes immense panic in the group.

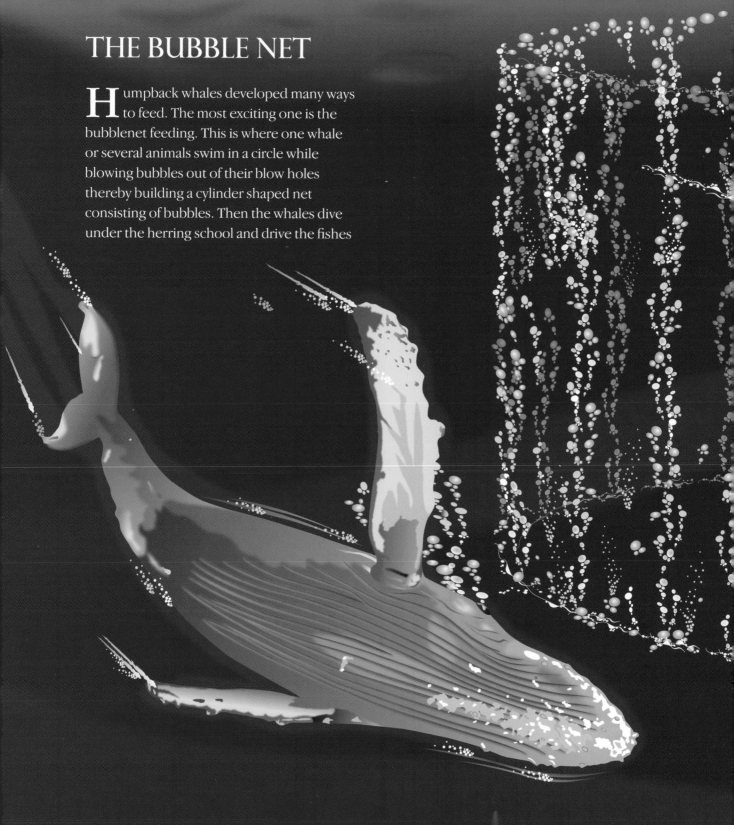

THE BUBBLE NET

Humpback whales developed many ways to feed. The most exciting one is the bubblenet feeding. This is where one whale or several animals swim in a circle while blowing bubbles out of their blow holes thereby building a cylinder shaped net consisting of bubbles. Then the whales dive under the herring school and drive the fishes

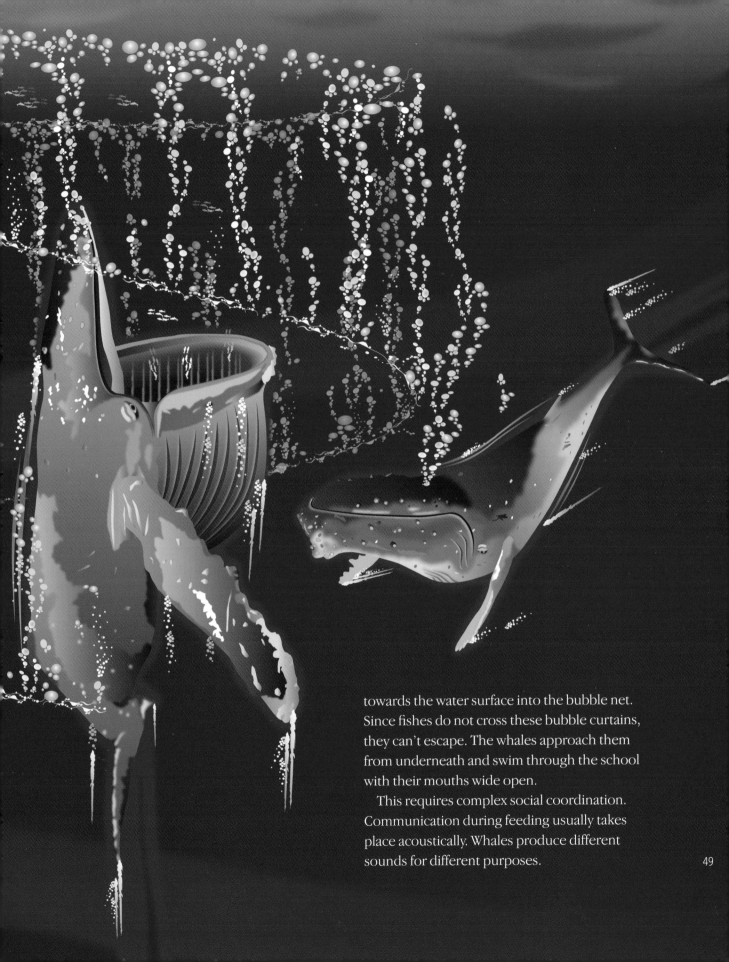

towards the water surface into the bubble net. Since fishes do not cross these bubble curtains, they can't escape. The whales approach them from underneath and swim through the school with their mouths wide open.

This requires complex social coordination. Communication during feeding usually takes place acoustically. Whales produce different sounds for different purposes.

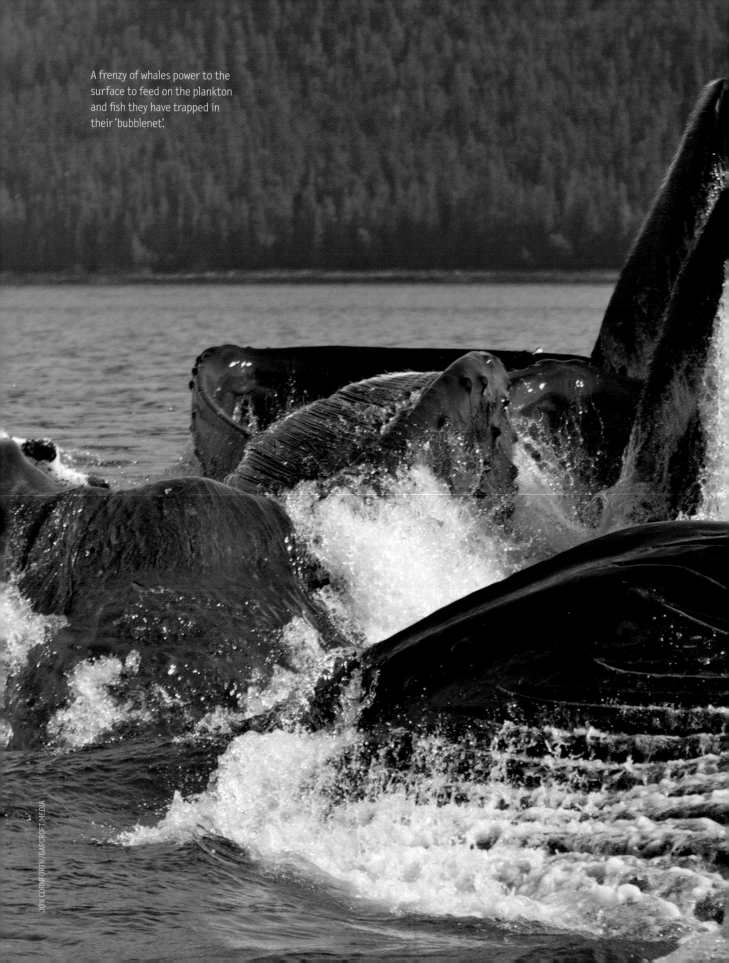

A frenzy of whales power to the surface to feed on the plankton and fish they have trapped in their 'bubblenet'.

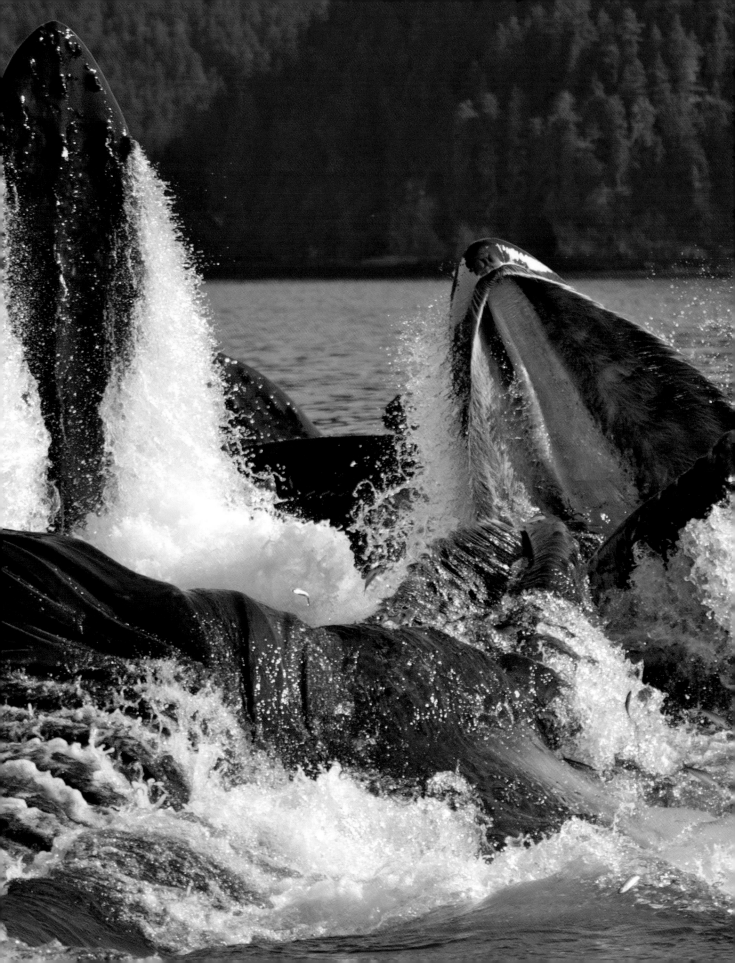

WHALE WATCH

Individual humpbacks generally only congregate into small groups for a few hours, although they can stay together for longer when feeding.

It is rare for pairings or groups to stay together for long but such events have been observed on occasion.

In the St Lawrence River of Canada females have been seen regrouping once a year, re-united to feed before going their separate ways.

Canadian scientists using "fingerpint" techniques – identifying the unique markings of each whale's colouring – have identified the same whales returning year after year.

A bonding that lasted six years was recorded during observations. It was always females of a similar age rather than male and female whales.

Interestingly the scientists believe that the bonding benefitted the females because they had more calves, probably as a result of group feeding patterns.

I lay on the boat reading. I ignored the wind, I refused to check its progress (for better or worse) throughout the day.

At 4pm it started to drop slightly, but it wasn't enough.

At 5pm, the captain crept up to the deck where we were all lounging and wallowing in our disappointment and asked, "Does anyone want to go and see some whales?" The wind had dropped off dramatically and a mother and calf had appeared just a couple of hundred metres from the main boat. I sprung into action, no more schoolgirl errors, this really was my last chance.

The skiff made painfully slow progress over the bobbing waves towards the whales. The sun was hung low in the sky, it was the magic hour for photography which was equally both a blessing and a curse. The light was beautiful, warm and golden – but it didn't have much power left in it and I was very aware that dusk was waiting in the wings, poised to take another opportunity away from me if we didn't get a spurt on!

Every time the whales made a dive down and disappeared my heart sank, we've lost them, they've gone but then soon enough they'd reappear again, but for how long? I was on the edge of my seat.

As we crept closer it soon became apparent that they weren't going anywhere, they seemed quite settled in their chosen spot.

I was first to enter the water and slid in nervously. My previous day's bravery had gone, whether it was the falling light or how animated the calf was being, there was a sense of unpredictability in the air and I was officially scared.

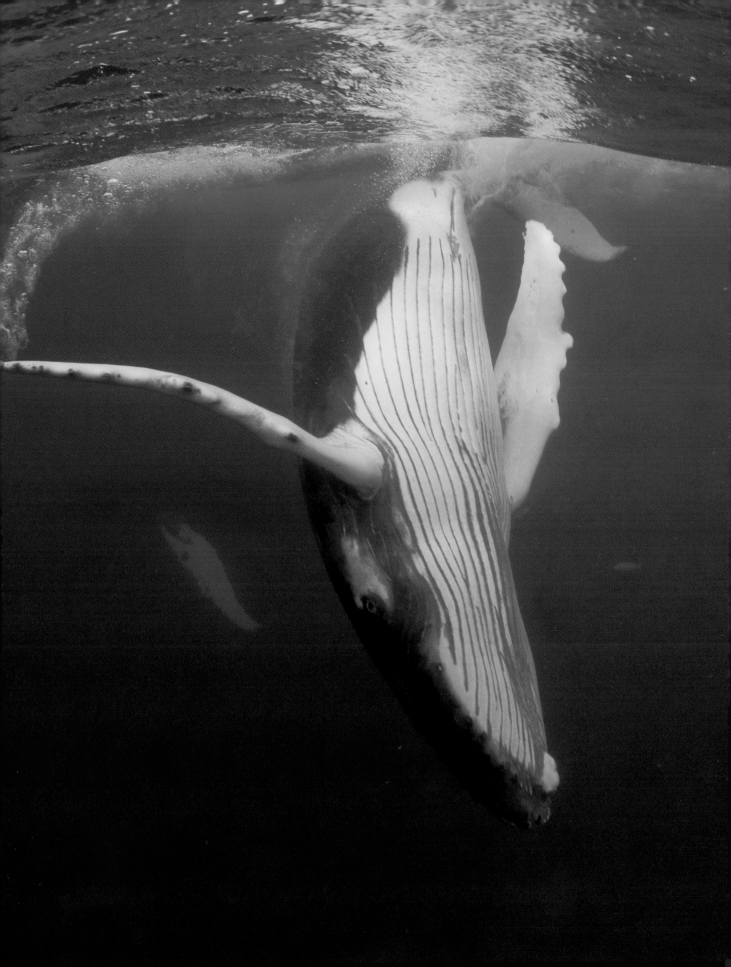

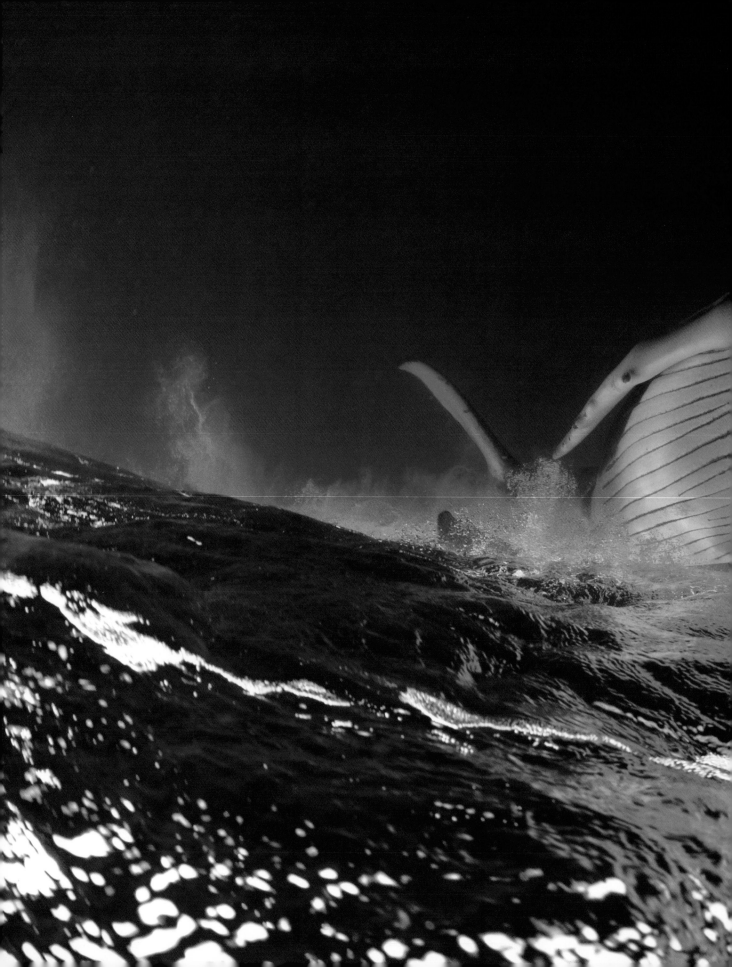

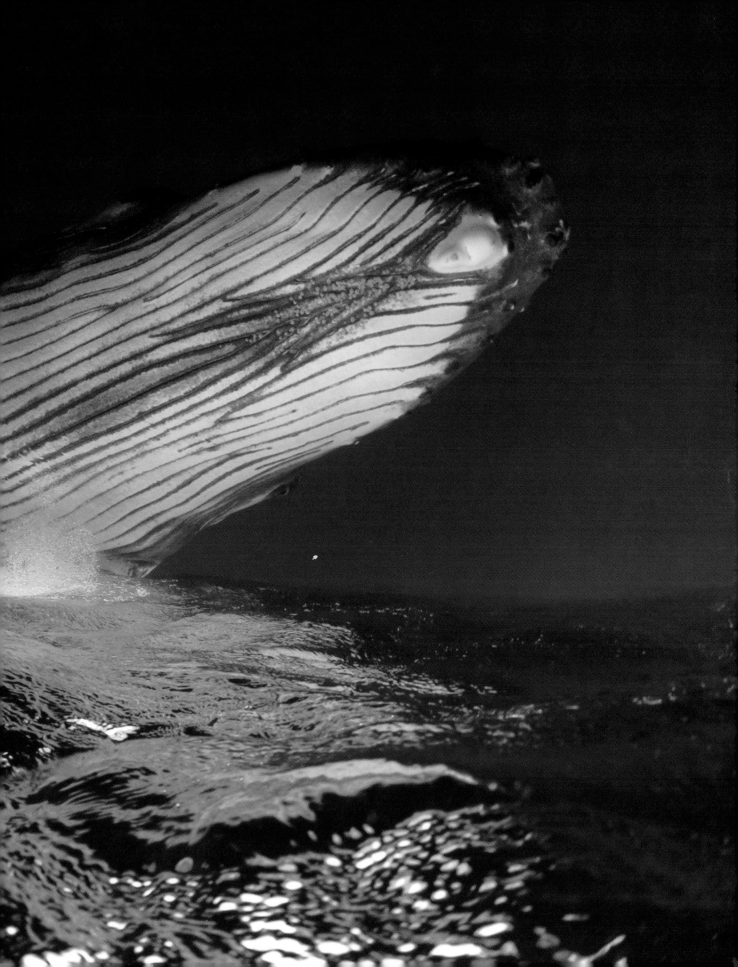

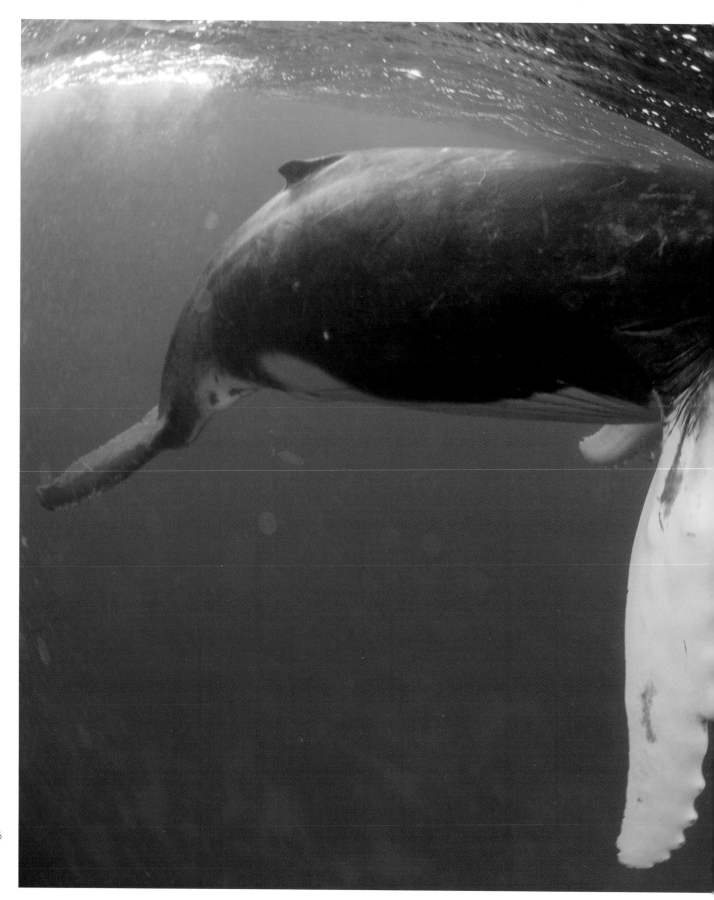

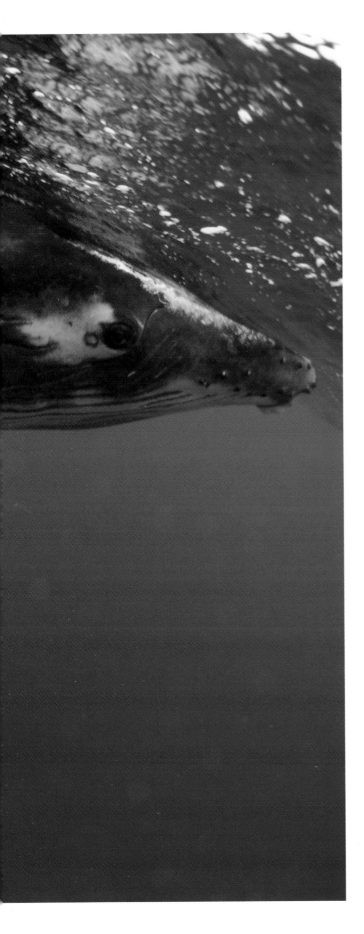

WHALE WATCH

Other than man, the humpback has few predators, but orcas or killer whales have been known to attack humpbacks. The result of these attacks is generally nothing more serious than some scarring of the skin, but it is likely that young calves are sometimes killed.

I floated with the dive guide 10 metres from the calf and his mother. The mother, just a few metres from the sandy bottom, was asleep. The calf was far from asleep. He circled her, nuzzled her and then to my horror, swam straight towards me. I didn't take my eyes off him through my lens and snapped continuously as he came closer. The dive guide held me steady and she was to tell me later that she had never felt anyone physically shake like I was doing in those first few moments. I was using a fisheye lens (a super wide angle) which makes things look very small in the frame unless they are within a few feet of you.

He filled my frame. I dared to look over the top of my camera and there he was, a few feet away looking me straight in the eye.

I'm not a marine biologist or a scientist and I can only draw on my own experience, but looking into his eye I felt there was an intelligence and a curiosity, certainly a sentient being, but it was more than all of these. He seemed to have a personality which became more apparent as the time went on.

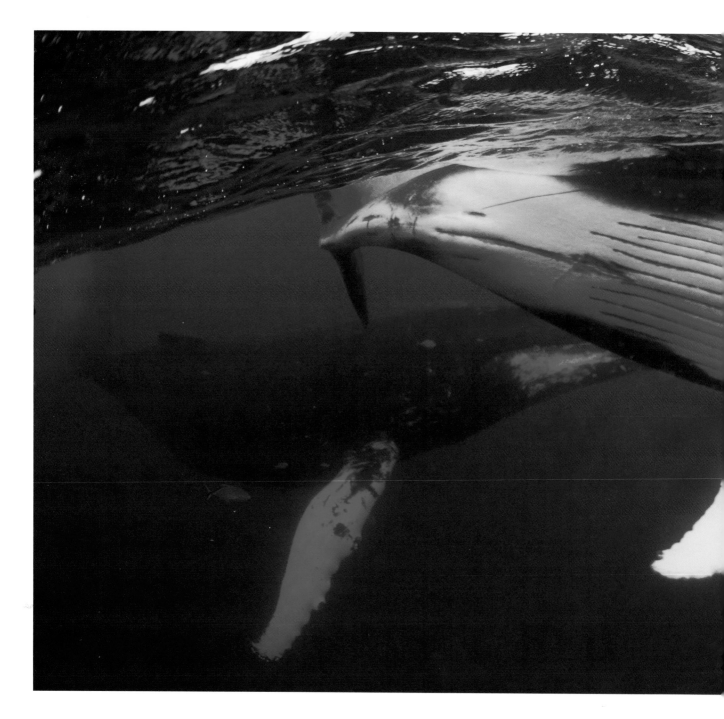

He swam right underneath me just a few feet away and I wobbled and bobbed uneasily in the water, worried I was going to kick him with my fin. I felt panic when he was this close as I didn't know how to place myself. He was in his element, his grace in the water only emphasised my gracelessness. I felt something similar to vertigo, like I was losing my balance and for those few moments when he was so close my eyes were like saucers, I didn't take a breath and I just stared at him wondering what the protocol was for meeting a whale face to face. Petting him would have been wildly inappropriate and patronising, plus touching

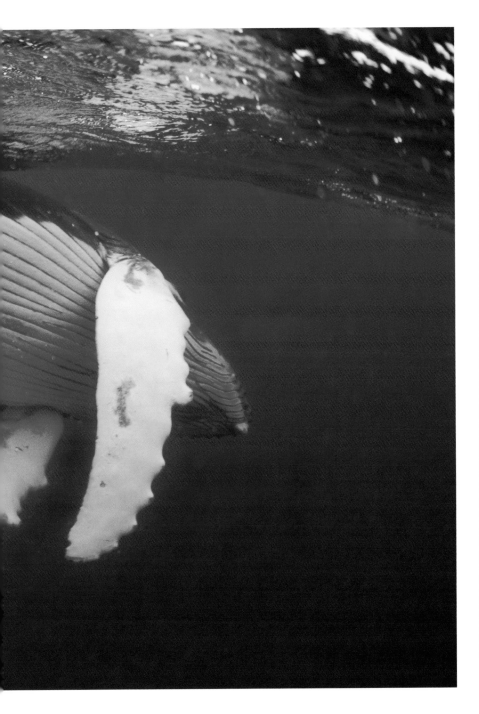

WHALE WATCH

Courtship rituals take place during the winter months, after migration toward the equator from feeding grounds closer to the poles. Competition among males can be fierce. Groups of up to 20 males can court a single female and exhibit a variety of courtship rituals to improve their chances of selection by the female. The size of the courting throng rises and falls as unsuccessful males withdraw and others arrive. Behaviors include breaching, spyhopping, lobtailing, tail slapping, fin slapping, and charging. Whale song is assumed to have an important role in mate selection; however, scientists remain unsure whether song is used between males to establish identity and dominance, between a male and a female as a mating call, or both.

the whales is not encouraged but there was something puppy-like about his playful nature and in his approach to me so perhaps that's why I thought about it. My dive guide was fantastic and reassured me by saying that I wouldn't kick him as he would move out of the way, he was well aware of his personal space and placement in the water whereas I seemed to have little control over mine, I was the fish out of water!

He breached and then tail slapped within 10 feet of me and then continued circling, and I shot continuously and hungrily as he carried out a 360 degree lap around me.

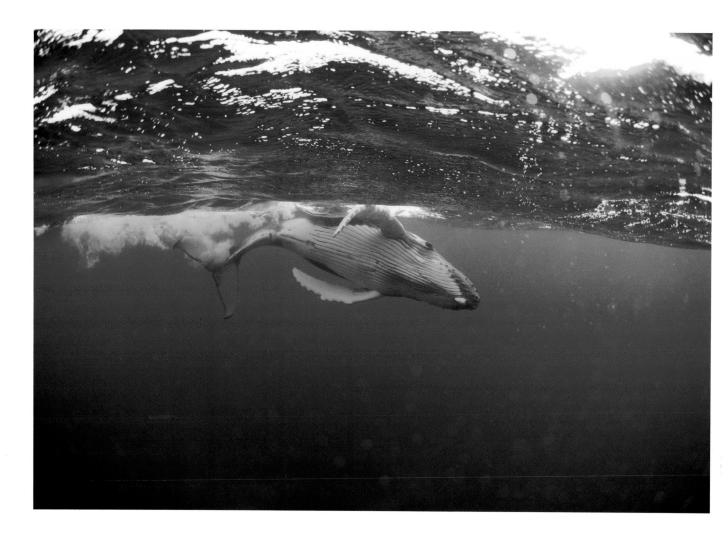

He started a routine; he'd swim to his mother and back to our small group. He would often swim straight to me, I believe because he could see his reflection in my camera dome port and then he would circle us. The initial shaking and shock subsided, but I couldn't help feel on heightened alert the whole time.

The adrenaline pumping, I kept on shooting. His movements were instinctive, he flowed from one position, it was captivating, gripping, terrifying.

Looking through a lens gives you a false sense of security and I certainly relied heavily on this for the first part of the encounter. Ridiculously, you can get so wrapped up in the shot that you forget about any potential danger – it's both a blessing and a curse. A couple of times I was snapped into the reality of the situation. The calf was making his routine circle and came very close and slapped his tail on the water a metre or so from my head. I froze for a few moments, slightly in shock, taking in both the seriousness of the situation and the fact that all was fine and decided that I'd had a lucky escape and started taking pictures again.

I was pulled erratically through a whole spectrum of feelings and emotions throughout the encounter. Fear, the natural fight or flight instinct that kicks in immediately when you feel like you might be in danger was what resulted in my shaky beginnings, I hold my hands up and say that if I hadn't had the experienced guide

there to steady me I may well have "flown" straight back onto the boat in a flash. Shock also played a big part in the beginning. The impact of the calf advancing towards me made me freeze and I was in that numbed state for a while, it was my body's way of coping with the paradox of thousands of years of evolution telling me to get out of the water, opposing my desire and curiosity to have this experience and see what would happen.

Instead of it being a quick, fleeting encounter, time was on my side and that meant I had the luxury of calming down and taking in exactly what was happening. Enjoying the experience, being amazed and captivated whilst it unfolded before my eyes rather than reliving a short encounter over and over on the surface. And in that state everything slowed down, I took in every detail, absorbed every movement, concentrated on how to capture the shots how best to represent the calf. I became aware of everything, it was vivid.

And then there were sudden moments where my heart leapt again, a tail slap, a breach a little too close for comfort, due to the unpredictable nature of an encounter like this I felt like I was living on the edge of my nerves. The sound of a tail slap would smash through the idea of my camera as a security blanket and remind me audibly of where I was and what I was doing.

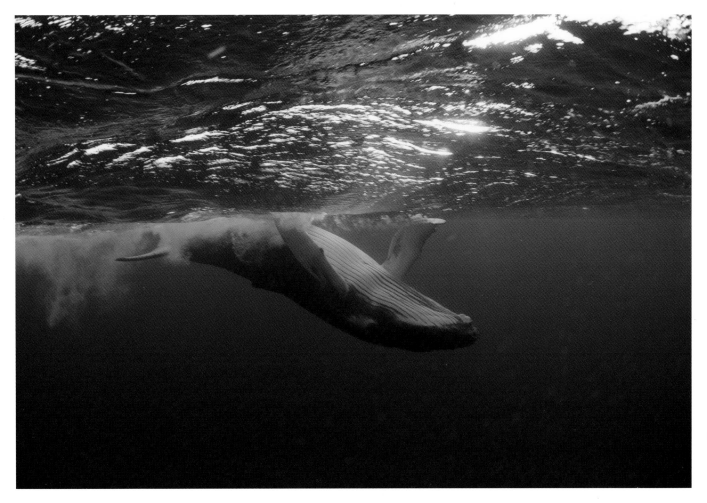

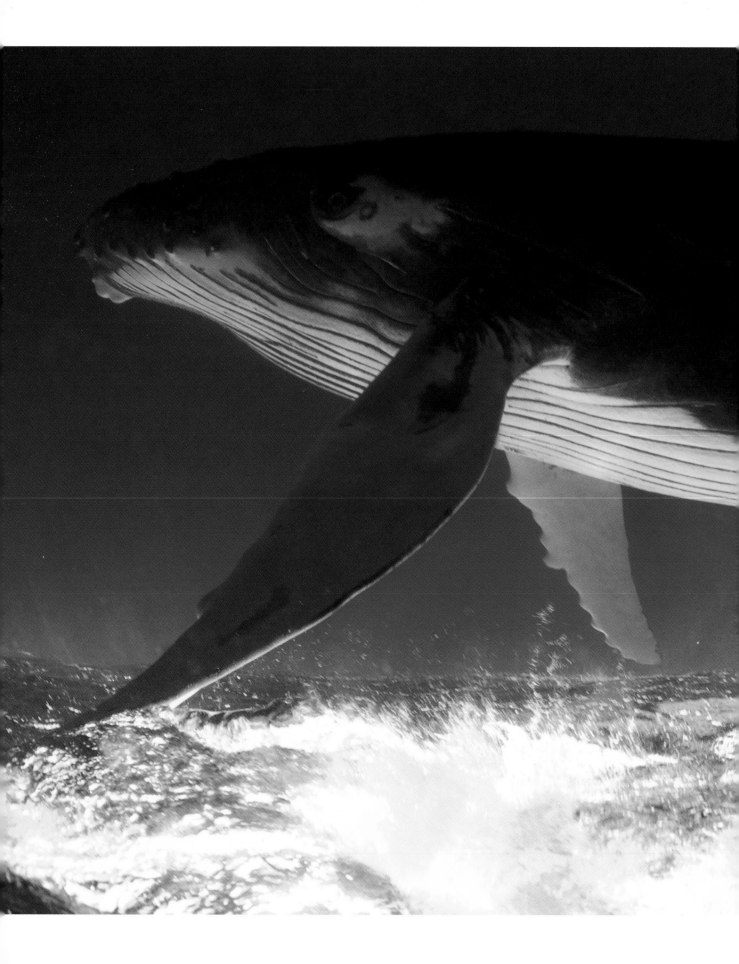

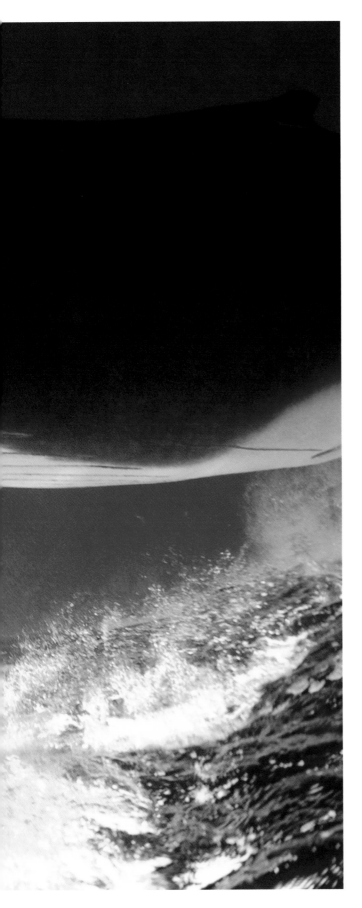

I was curious to know what he was getting out of the encounter. Us snorkellers were still, entities floating on the surface, unable to join in with his spectacular ballet or (apart from eye contact and bobbing around a bit) really physically interact with him. Essentially, I thought, we must have seemed quite boring to him.

As the light began to fail after about an hour in the water it felt very fitting, the encounter was coming to a natural close as the sun was going to set. It was nature's way of saying "cut". And at this point he completed what was to be his final lap of us and returned to his mother once more who was surfacing to breathe. After a few moments together on the surface, they were both very quickly gone.

The magnitude of the experience of being in the water next to a whale means that you forget about other factors that once concerned you, like the fact that you are in open ocean or what other dangers might be lurking below you. It all becomes relative and your immediate concern becomes only the creature heading straight for you, it focuses the mind. In the same vein I forgot immediately how cold I was and didn't think about it again until I was back in the boat.

I chose to display some of the images upside down because I like the fairytale quality that it gives them.

WHALE WATCH
The heart of the average humpback whale weighs about 195kg — as big as three average adult humans.

There was something slightly otherworldly about the experience, the subject matter coupled with that beautiful yet ominous dusk light and displaying them like this reflects the atmosphere of the encounter for me. It looks like a fantasy world; I imagine it to be like *Alice in Wonderland* if she had landed in water, where everything just isn't quite as it should be and makes you look twice.

MY BACKGROUND

For me, being underwater is the perfect antithesis to the world upstairs, away from technology and human disturbances; there's just the gentle sway of the current and the noise of your breath. It forces you to slow down and is a great place to potter. It is also a great place for adventure.

I studied Underwater Photography at Falmouth College of Art in Cornwall from 1997-2000. It was not so much a learning curve as a vertical face, especially as I learnt in the time of film (pre-digital). I cut my teeth on trips to the Red Sea and on lots of pool work involving subjects that spent time underwater, synchronised swimmers, babies learning to swim, surf life savers who were training. I loved it.

Underwater photography isn't an ideal choice of career for a perfectionist as there are so many things that can go wrong and so many variables that are out of your control. On the technical side I've learned the hard way, making many, many mistakes and when it comes to nature, I've learned to be patient and accepting (most of the time!).

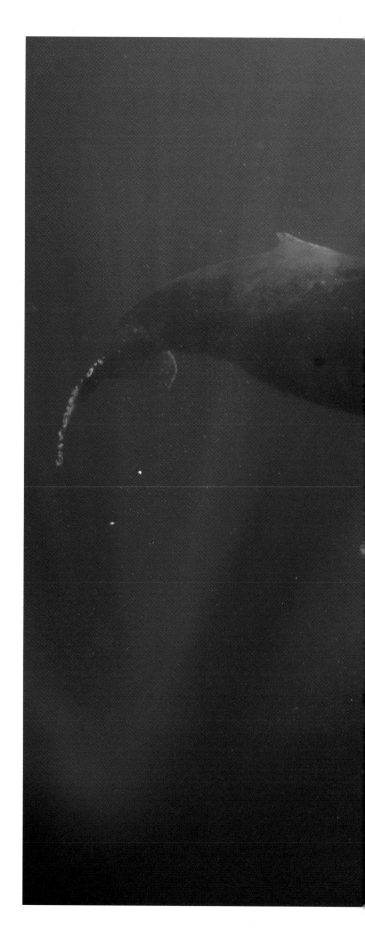

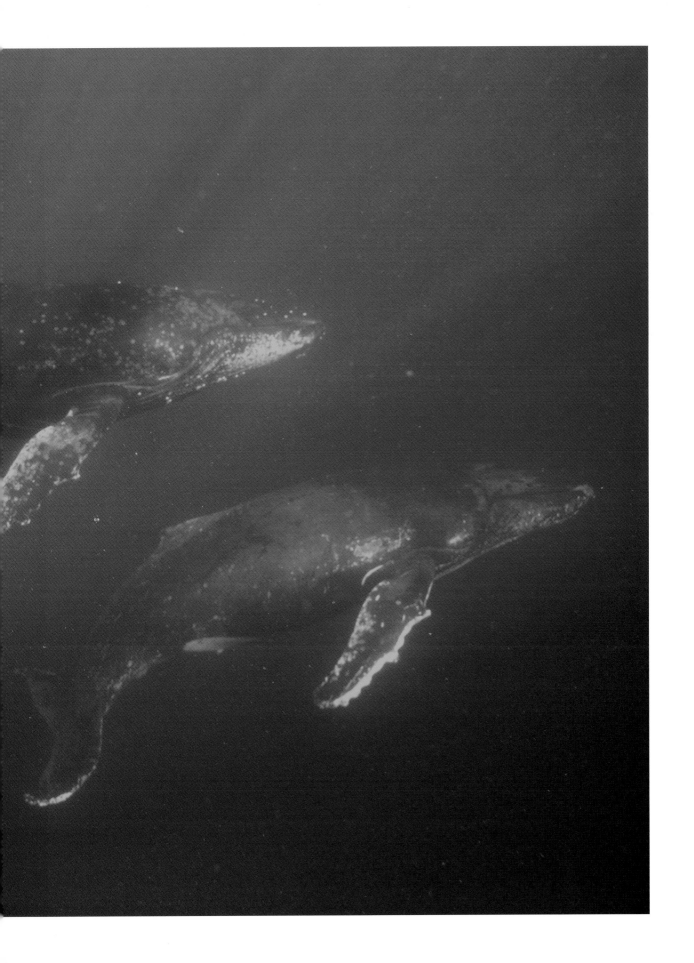

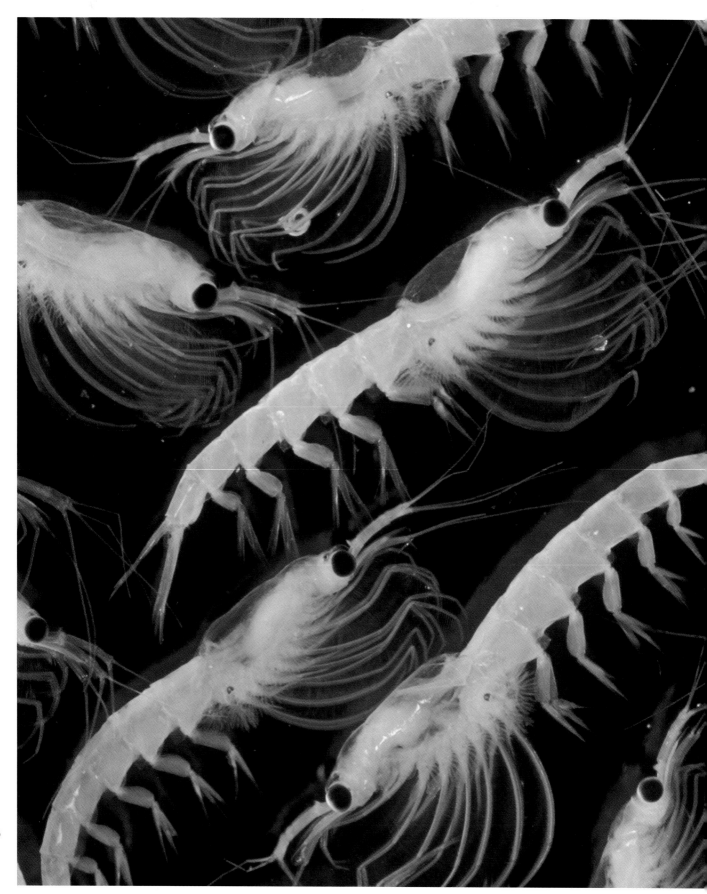

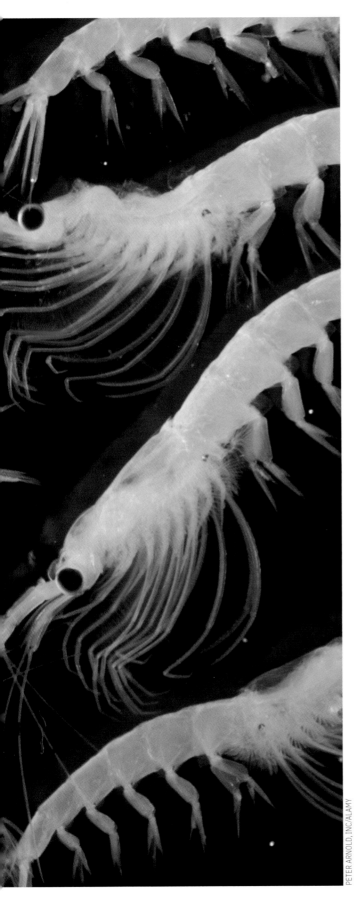

WHALE FOOD

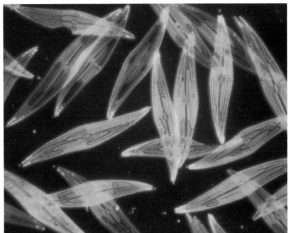

SCIENCE PHOTO

K rill is the common name given to shrimp-like marine crustaceans. Also known as euphausiids, these small invertebrates are found in all oceans of the world. The common name krill comes from the Norwegian word krill meaning "young fry of fish".

Krill are near the bottom of the food chain – because they feed on phytoplankton and to a lesser extent zooplankton, converting these into a form suitable for many larger animals for whom krill makes up the largest part of their diet. Krill is eaten by whales, seals, penguins, squid and fish.

A humpback will typically eat up to two tonnes of krill, plankton, or herring twice a day storing up calories for the winter.

Above: The food chain begins with phytoplankton which in turn are eaten by a whales main source of nutrition – krill.
Left: krill.

PETER ARNOLD, INC/ALAMY

Commercial fishing of krill is done in the Southern Ocean and in the waters around Japan. The total global harvest amounts to 150,000–200,000 tonnes annually, most of this from the Scotia Sea. Most of the krill catch is used for aquaculture and aquarium feeds, as bait in sport fishing, or in the pharmaceutical industry. In Japan and Russia, krill is also used for human consumption and is known as okiami in Japan.

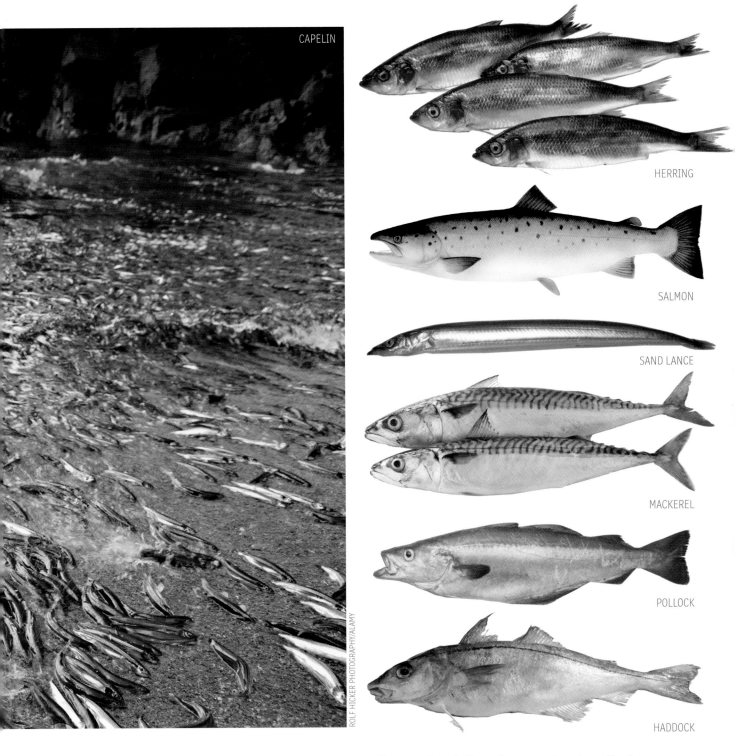

CAPELIN

HERRING

SALMON

SAND LANCE

MACKEREL

POLLOCK

HADDOCK

ROLF HICKER PHOTOGRAPHY/ALAMY

Krill are about 2 inches in length.

The humpback is an energetic hunter, taking krill and small schooling fish, such as herring (*Clupea harengus*), salmon (*Salmo salar*), capelin (*Mallotus villosus*) and sand lance (*Ammodytes americanus*) as well as Mackerel (*Scomber scombrus*), pollock (*Pollachius virens*) and haddock (*Melanogrammus aeglefinus*) in the North Atlantic. Humpbacks hunt larger prey by direct attack or by stunning prey by hitting the water with pectoral fins or flukes.

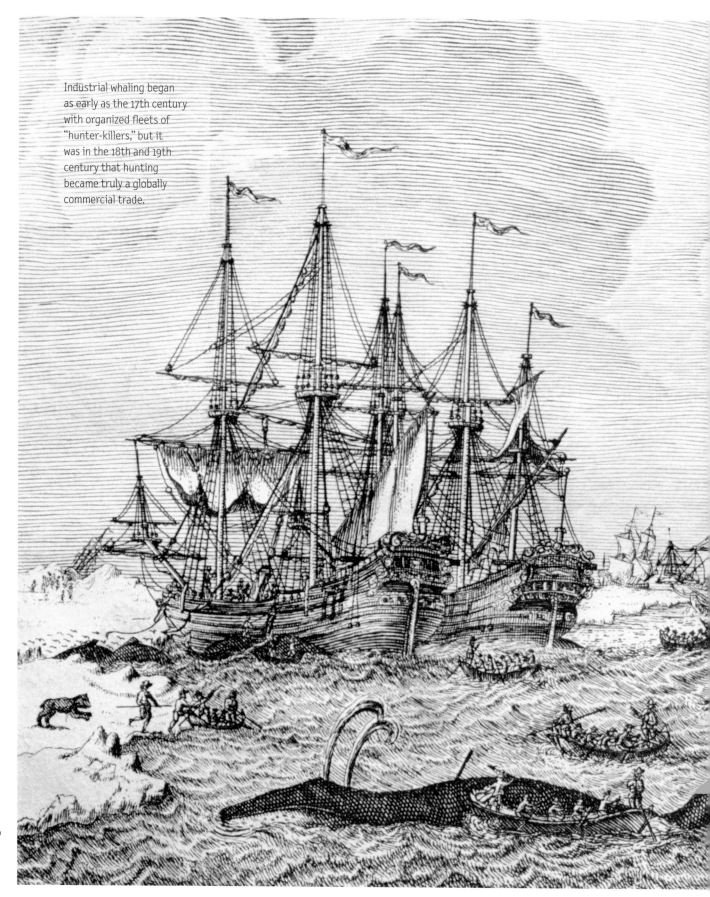

Industrial whaling began
as early as the 17th century
with organized fleets of
"hunter-killers," but it
was in the 18th and 19th
century that hunting
became truly a globally
commercial trade.

A HISTORY OF HUNTING

The hunting of whales began in prehistoric times dating back to about 6000 BC. It began with organised fleets in the 17th century, competitive national whaling industries in the 18th and 19th centuries, to the introduction of factory ships and the introduction of the concept of whale 'harvesting' in the 20th century. Whaling was spurred on by the increase in the demand for whale oil, margarine and whale meat.

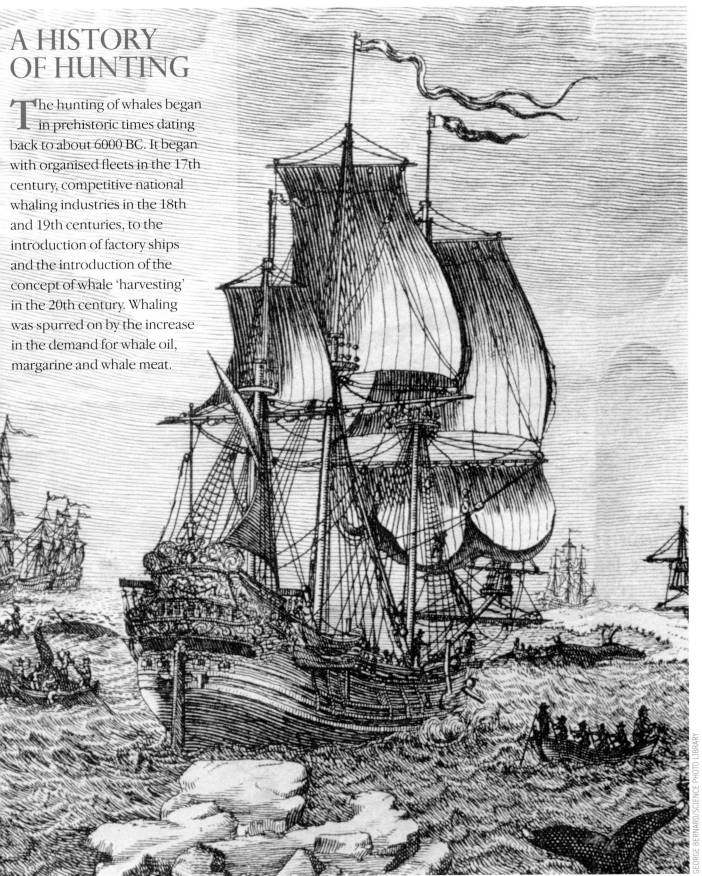

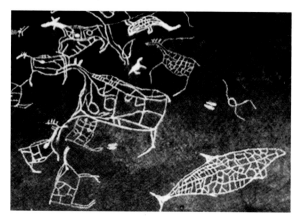

The oldest known method of whaling was to drive them ashore by placing a few small boats amongst the animals to frighten them with noise and activity, herding them towards the shore to beach. This method was mostly used for small species, such as the Pilot Whale, Beluga, Porpoise and Narwhal. Next, they used an object called a drogue, such as a wooden drum or inflated sealskin which they tied to an arrow or harpoon, in the hope that the whale would tire enough to be approached and killed. Evidence suggests that this practice began as early as 6000 BC in South Korea. But whaling with drogues was especially practiced by the Ainu, Iniut, Native Americans and people of the Bay of Biscay. Rock carvings have also been unearthed showing several Sperm Whales, Humpback Whales and North Pacific Right Whales being surrounded by boats.

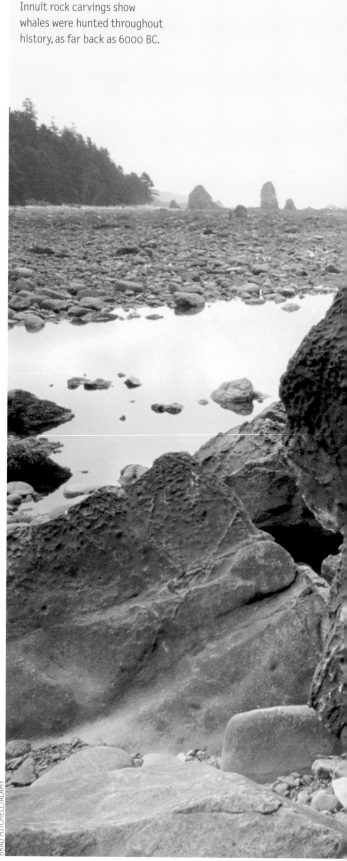

Innuit rock carvings show whales were hunted throughout history, as far back as 6000 BC.

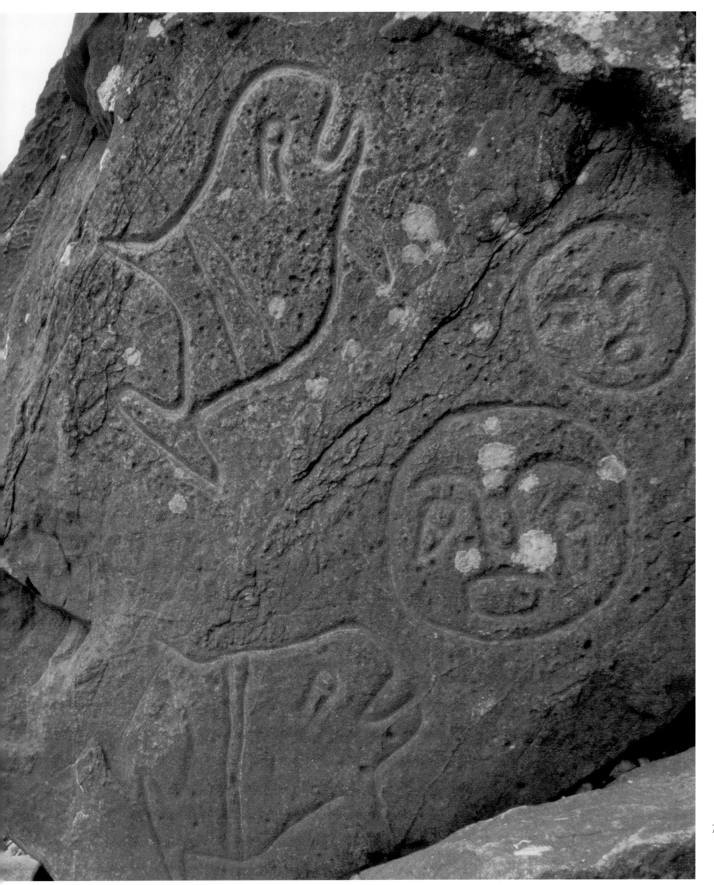

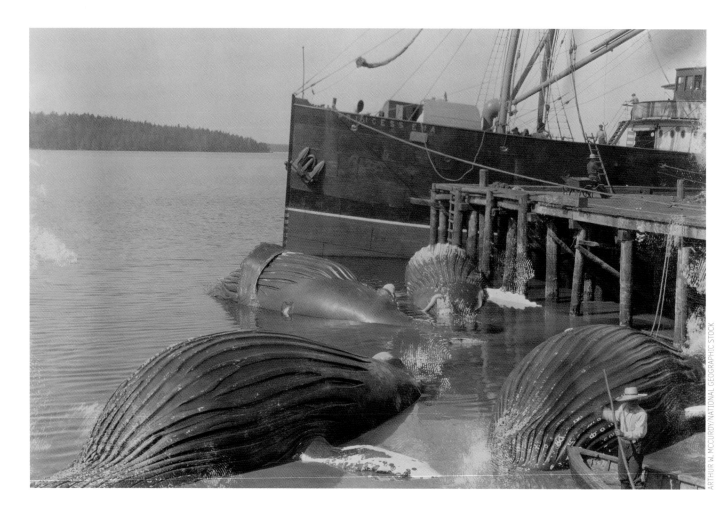

The Princess Ena docks to take on its cargo of whale oil and blubber along the coast of British Columbia in the North Pacific in the early 20th century: ships like this helped drive whales to the point of extinction.

The first European Whalers were the Basques, from the Bay of Biscay. The Right Whale was very common there, and became favoured prey even through to the 18th and 19th centuries, as they were slow swimmers and their bodies floated. But during the 11th century, they found that these whales were very profitable to slaughter once they had beached. They realised the blubber could be used for lighting fuel and the meat could be eaten. These strandings became advantageous, but they eventually started driving them out the water. Basque whaling continued until the start of the Seven Years War in 1756.

This became a highly organised business by the 12th century. They built stone watchtowers and once a whale was sighted, an alarm was

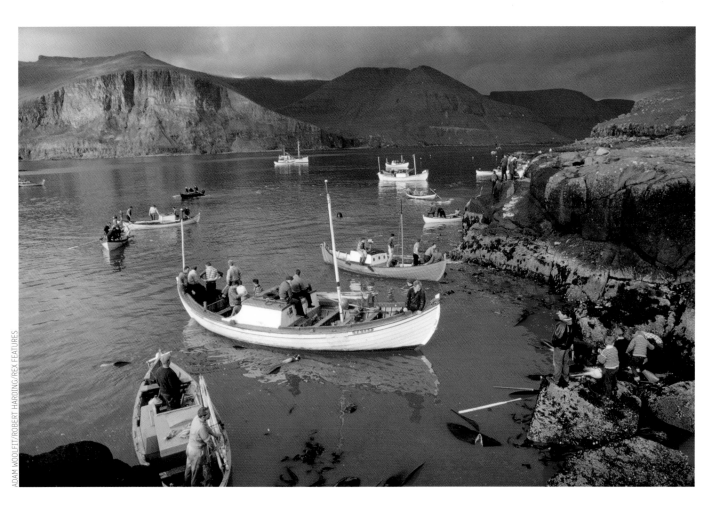

sounded and as many as 20 villages would head out after it. They would share the rewards, except for the tongue, which was given to the church as a favoured delicacy. Soon the British and Dutch began whaling. For many years they used Basques as expert whalers on their ships.

Whale oil is scarcely used today, so modern commercial whaling is mainly the hunting of whales for food, as well as for scientific research purposes. The primary species of whale that is hunted is the Common Minke Whale and the Antarctic Minke Whale.

Many countries began joining in whaling, with many species of whales being in danger of extinction. This caused the beginning of the global anti-whaling movement in the 1970's.

Scenes like this disgust many, but some countries, namely Japan, Norway and Iceland still hunt whales. Others, whose communities have a long history of dependence on hunting claim "aboriginal" or "traditional" rights to continue.

THE WHITE WHALES

White whales are not just the stuff of Herman Melvillie's imagination as chronicled in his epic novel of the notorious *Moby Dick*.

Though rare, there have been many sightings of these magnificent animals, which are in fact albinos and some have become celebrities, with avid followers, protectors and admirers.

Migaloo is the only known all-white humpback whale in the world. First sighted in 1991 and believed to be 3–5 years old at that time, Migaloo is a word for "white fella" from one of the languages of Indigenous Australians. Speculation about Migaloo's sex was resolved in October 2004 when researchers from Southern Cross University collected sloughed skin samples from Migaloo as he migrated past Lennox Head, on the New South Wales coast of Australia and subsequent genetic analysis of the samples proved he is a male.

Because of the intense interest, environmentalists feared that he was becoming distressed by the number of boats following him each day. In response, the Queensland and New South Wales governments introduce legislation each year to create a 500m (1600ft) exclusion zone around the whale. Recent close up pictures have shown Migaloo to have skin cancer and/or skin cysts as a result of his lack of protection from the sun. In 2006, a white calf was spotted with a normal humpback mother in Byron Bay, New South Wales.

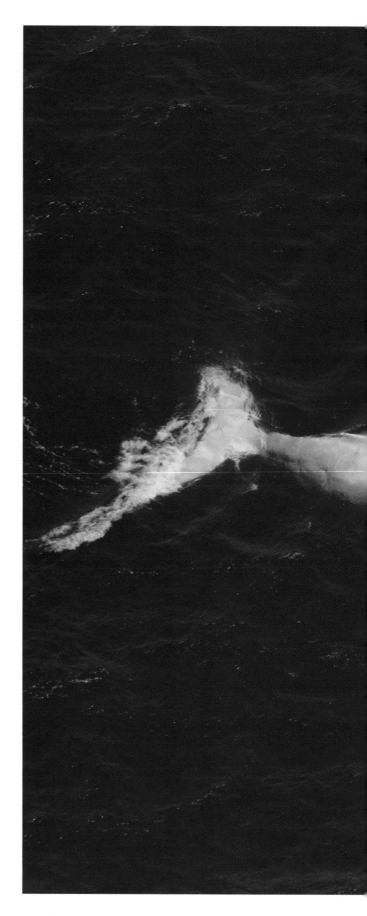

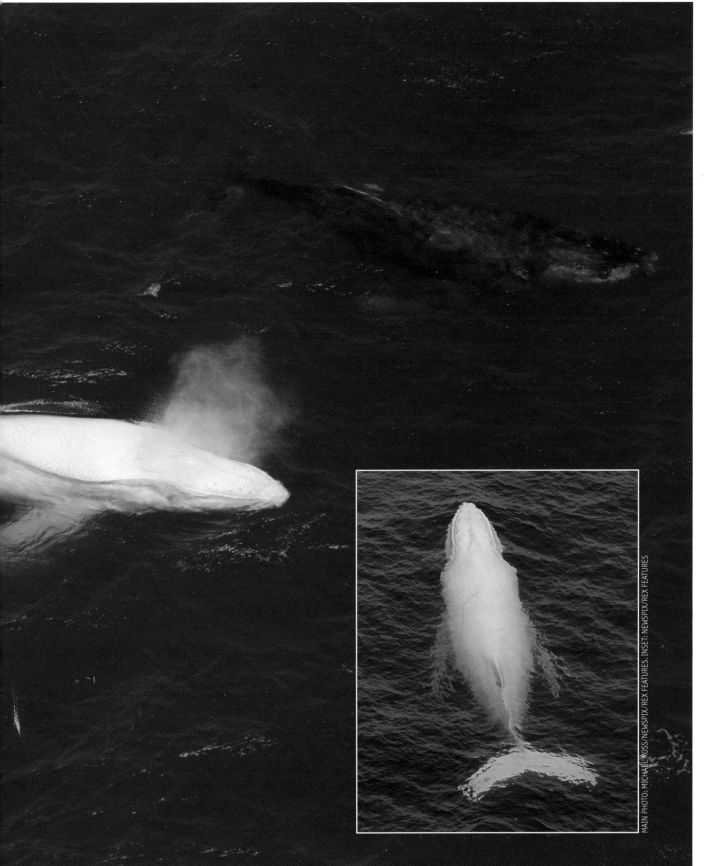

MAIN PHOTO: MICHAEL ROSS/NEWSPIX/REX FEATURES. INSET: NEWSPIX/REX FEATURES

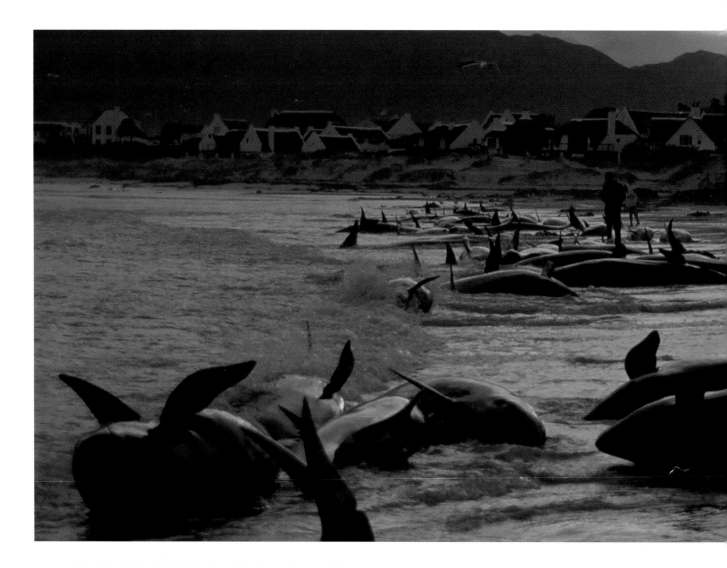

WHY WHALES BEACH

An entire pod of beached whales is a heartwrenching sight and in many countries of the world provokes frantic efforts to save them, or if all is lost, to release them from a lingering and painful death.

Whales rarely survive being driven ashore and beaching or stranding themselves. They die either from dehydration from prolonged exposure, or because their lungs collapse under their own body weight. Sometimes they drown as the incoming tide covers their blowhole.

In spite of valiant efforts by humans, it is rare for a whale to be saved and returned to the sea. And often they will only beach themselves again, as if they have a death wish.

Thousands die every year by beaching and sometimes an entire family group will mass-strand itself. Many theories have been put forward to explain the phenomenom but no scientific proof has yet been discovered to fully explain it.

Theories range from disorientation caused by human activity such as naval sonar and noise pollution, but since whale strandings have been recorded throughout history there may be many

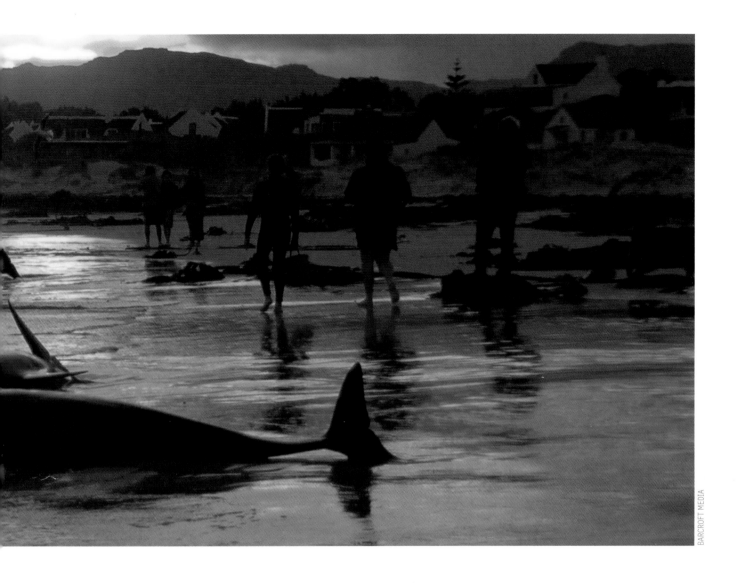

reasons, including storms, old age and infirmity, or feeding too close to shore in shallow waters.

Among some species a single stranding can lead to an entire pod of whales beaching itself. Social cohesion leads the pod to answer a stranded whale's distress calls thus beaching en masse.

Some scientists believe it may be possible to train dolphins to lead stranded whales back out to sea, once floated in shallow waters. Whales which are used to hunting in shallow water, such as Orcas, rarely beach, and in some regions have learned to beach and extricate themselves.

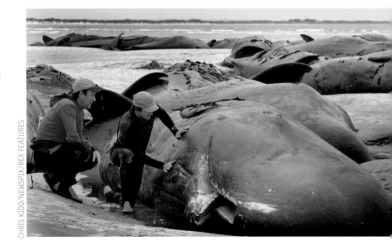

Other Wildlife Monographs titles published by

Evans Mitchell Books
www.embooks.co.uk

Wildlife Monographs
Snow Monkeys
ISBN: 978-1-901268-37-9

Wildlife Monographs
Living Dinosaurs
ISBN: 978-1-901268-36-2

Wildlife Monographs
Brown Bears
ISBN: 978-1-901268-50-8

Wildlife Monographs
Monkeys of the Amazon
ISBN: 978-1-901268-10-2

Wildlife Monographs
Polar Bears
ISBN: 978-1-901268-15-7

Wildlife Monographs
Cheetahs
ISBN: 978-1-901268-09-6

Wildlife Monographs
Leopards
ISBN: 978-1-901268-12-6

Wildlife Monographs
Sharks
ISBN: 978-1-901268-11-9

Wildlife Monographs
Penguins
ISBN: 978-1-901268-14-0

Wildlife Monographs
Elephants
ISBN: 978-1-901268-08-9

Wildlife Monographs
Dolphins
ISBN: 978-1-901268-17-1

Wildlife Monographs
Wolves
ISBN: 978-1-901268-18-8

Wildlife Monographs
Puffins
ISBN: 978-1-901268-19-5

Wildlife Monographs
Giant Pandas
ISBN: 978-1-901268-13-3